TAKING BETTER
PHOTOGRAPHS
Norman Tozer

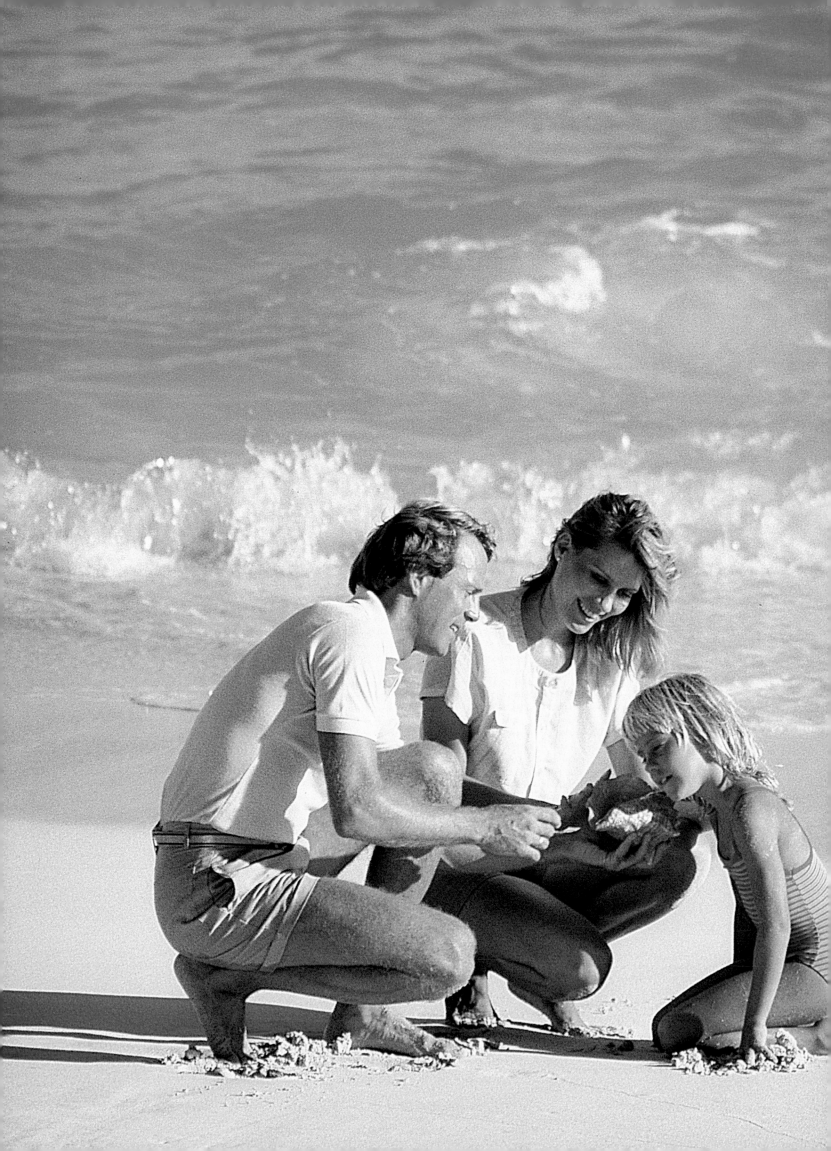

TAKING BETTER
PHOTOGRAPHS
Norman Tozer

Published in 1995 by Grange Books
An imprint of Grange Books PLC
The Grange
Grange Yard
London
SE1 3AG

ISBN 1 85627 709 7

Printed & bound by ORIENTAL PRESS, (DUBAI).

Right:

**Stone Hall of the Nymphenburg
Palace, Munich, Germany.**

CONTENTS

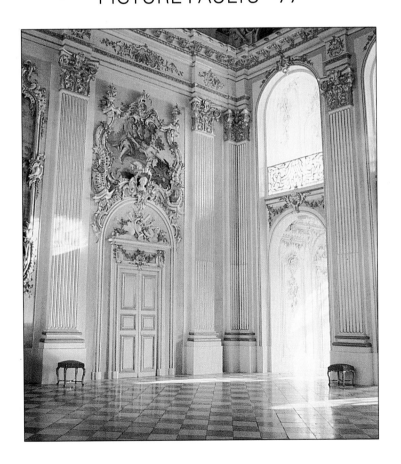

INTRODUCTION

THIS BOOK is for all those people who want to take family album photographs that look in some way special. If you are new to photography you may want some tips on choosing a camera, or you may already have a basic-to-medium price one but would like to get more out of it. Also, it is probable that you would prefer the technology to take care of the technical matters, leaving you free and confident to enjoy taking pictures. As a result, the physics and optics involved in photography is not discussed here and there is only an outline of the technicalities of processing – just in case you are thinking of photography as a future more involving hobby.

As a family or occasional photographer you want to put in the picture all that you think you see – even though that may include a hope or a memory. You take pictures to tell a story – records of a journey or a person, a mood or a memory – or to impress. The problems arise if you try to ignore, or compete with, the photographic technology. This book will demonstrate that although there are a few rules to picture-making, they are easily absorbed and need not inhibit you; indeed they can actually open the way to a more realistic understanding of the opportunities and limits for the imaginative preservation of your memories.

The idea is not to read the book from start to finish in one go; rather dip into it, taking subjects as you fancy and as you want to learn and use the information. In this way you will find that your curiosity will soon help to increase your skill.

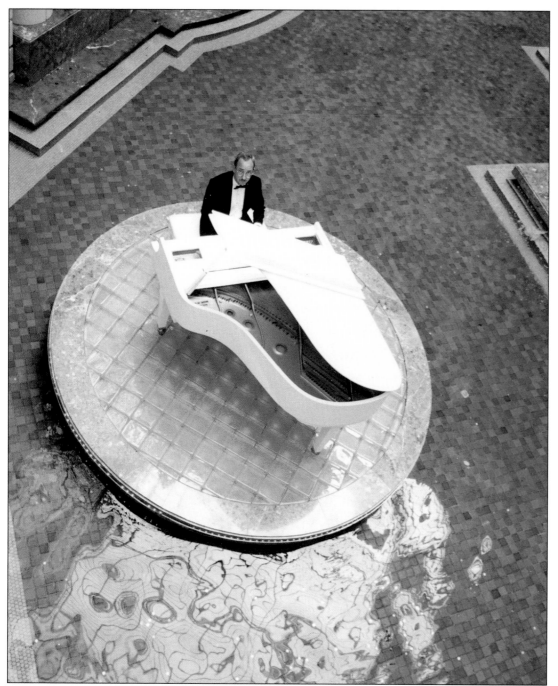

Left:
A shopping mall in Washington, DC. A pianist on his own 'island'.

Right:
The right moment. The ghostly atmosphere around this country folly was created by a slow shutter speed blurring the bushes and trees as they flashed past the photographer in a fast train.

THE BASICS

IT IS SAID that a good photograph is the result of being in the right place at the right time. For example, if you are at someone's birthday party – particularly if they are very young or quite old – there will be a cake and obviously it will be the focus of activity and smiles. However, there is more to it than just that.

A good photo – one worth putting in the album or framing – will not only reflect what occurred, but also the atmosphere of the occasion. So you have to know or 'right-guess' what will happen, and when; then you need the co-ordination of eye and muscle to aim, frame and squeeze the shutter-release at exactly the moment to record the image for a perfect picture. At that split second you must be neither too high nor too low, neither too much to the left or right, and neither too much in front or behind your subject to capture it. Your film has to be both the right speed and colour balance for what you intend to do with the image afterwards; the camera aperture must let in exactly the right amount of light for a good exposure and the speed of the shutter must so match any movement that it will – by its clarity or amount of blurring – suggest the character precisely. The focusing will direct the eye within the composition to where it can best start its exploration and interpretation of the shades, lines and colours that make up your family snapshot.

Rarely can all this happen by accident! It is possible to learn to do all these things for yourself, or alternatively, many of today's cameras can do them automatically. However, when it comes to choosing the precise spot from which to take the picture – and that split second of time when you press the shutter button – there is simply no technology to take over. These two decisions are yours alone; getting them right for each shot is the excitement and ultimate reward.

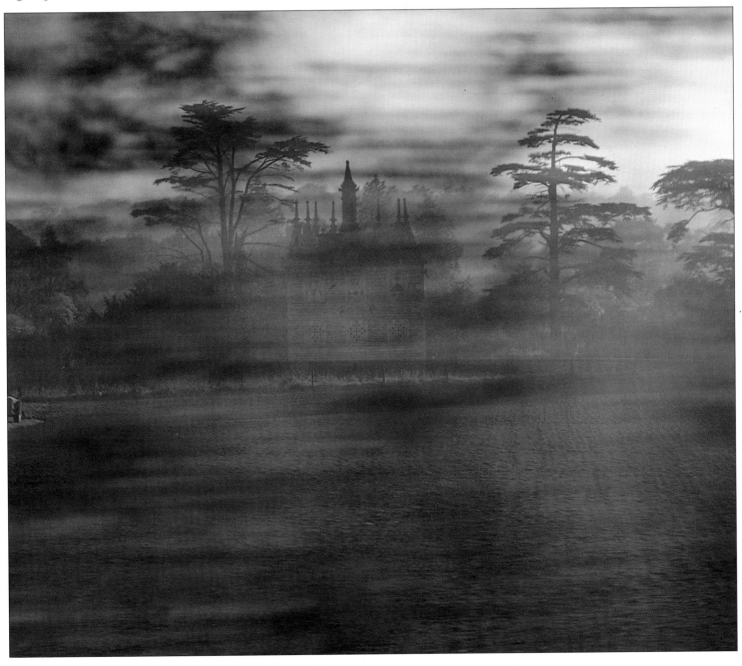

ASSETS YOU CANNOT BUY

LIGHT

Our eyes are naturally drawn towards light. Quite unconsciously, we use bright and dark, the direction of a shadow, the colour of light to give us a mass of information about distance, shape and time. To take really good photographs you need to observe, appreciate and understand light.

Light has intensity, direction and colour. Its intensity is easy to understand when we see sunlight. The source is visible, its deep shadows obscure. But the atmosphere refracts light, scattering it as it passes through; so many surfaces reflect light that there is hardly ever a time when a shadow is wholly obscure, when it is not possible to see some detail in it. Often the technology of photography forces us into a choice; if it will not allow us to show clearly what is happening in the light and also in the shadow which is the true picture? Is there a possibility of some sort of compromise?

The direction from which light falls gives things shape but also tells us about the time of day. In addition, it can reveal or distort faces, making us believe different things about a person's character. If the light is very high the cheekbones become prominent and the jaw looks firmer but it causes dark eye sockets, emphasizes bags under the eyes and brings out wrinkles. What sort of person is this?

As the light source is lowered, so the wrinkles become less obvious but the face becomes flatter and fuller, the jawline softer and the eyes clearer. Has the personality changed now?

Finally, with the light falling from one side, only part of one eye can be seen, one ear dominates that side of the head and the nose catching the light seems large. Is the light now deceiving or actually more revealing?

Colour in light is more difficult to see objectively; our brains tend to compensate for it and normalize it. We may enjoy being bathed in the glow of the evening sunset but how many of us notice the blue cast over faces in the shade on a bright day or the green cast thrown by some fluorescent lights? And do we ever register how yellow our faces have become as we step into the light of our domestic lamps?

Only when you can understand light and its effects can you know if what you see will make a good photograph.

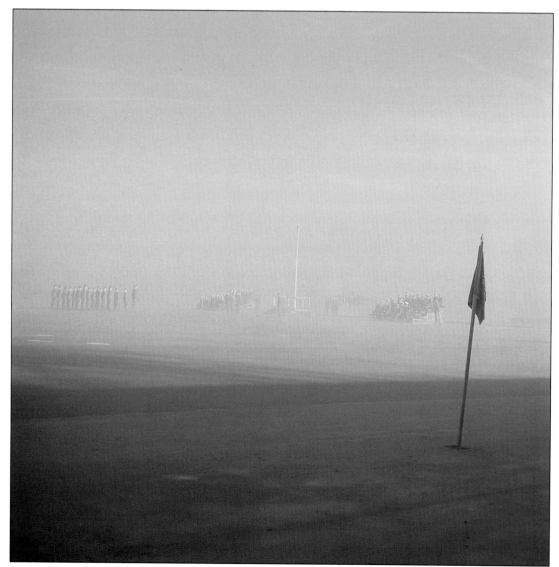

Left:
Pictures do not always come from strong, clear light. The way that mist, fog or smoke can soften lines and colours makes mysterious often intriguing images, and gave a ghostly quality to this morning military parade. The clarity of the banner in the foreground emphasizes the softness of the rest of the scene.

Left:

Despite the problems of exposure that shooting towards the sun can cause, the contrasts in this shot capture all the sparkle of summer on the beach.

Above:

If you have strong clear light it is not always necessary to have it behind you, falling straight on to the subject. Light helps define shape; here it also gives depth.

A CHECKLIST FOR LIGHT

▪ Is there enough light?

▪ Is it hard or soft?

▪ Does it define the subject? Does it make it look the correct shape?

▪ Can you see enough detail?

▪ Does the colour of the light look right?

▪ Will the picture improve if you change the light? If so, should the light, or the subject, or the camera move?

COMPOSITION

Most people do not compose a picture consciously; a very few can do so instinctively but most of us have to learn how. It would be very unusual for someone to stop at a view or a crowd of people and think what wonderful ovals, circles or triangular shapes they would make in a photo. Mostly what happens when we see a landscape or a fairground is that we are moved or thrilled by the sight, sound and smell and just take a picture. Then, when we see the result – dull, distant hills or people standing in front of the big wheel – we feel a sense of disappointment and frustration. How did we lose that majesty or excitement? The answer is almost certainly by bad composition.

Good composition draws your eyes into the picture, then moves them around with an energy that reflects the subject and also allows you to pick up more details on the way. It may keep your eyes moving or it may let them finally rest somewhere in the picture – but how does it achieve this?

In everyday life your eyes continually scan your surroundings and are always drawn towards the light. The same happens when you look at a photograph – your eyes automatically seek the brightest spot of light or colour. Your eyes are helped in this process if they have lines to follow, but a line is only visible because it contrasts with its background. These lines and areas of light and dark are naturally of more interest if they are recognizable to us as familiar things – houses, trees, people. However, when they are assembled and confined as an image we are also more satisfied if they make up certain patterns. Artistically our senses seem to prefer triangular and circular shapes.

The best way to learn about composition is to look first at photos taken by other people or even your own old ones. Use the points discussed here to analyze them critically and then put each point into practice as you take your own photos. Ultimately it should become second nature to you.

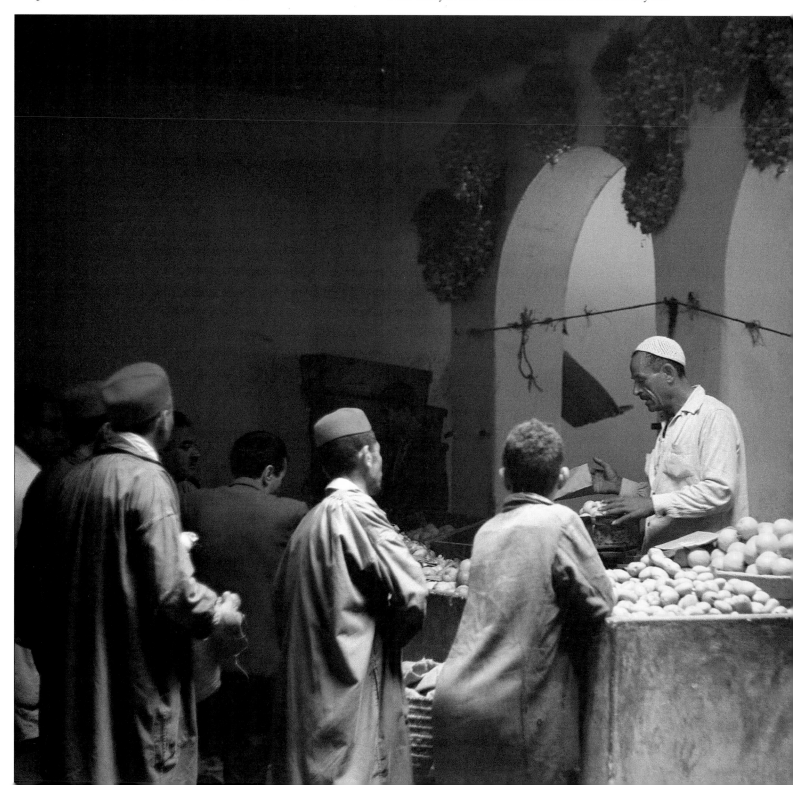

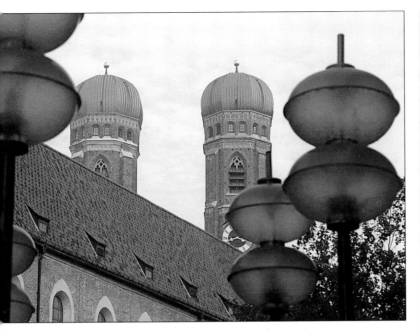

Above:
A composition in circles. The domes of the Cathedral Church of Our Lady, Munich, echoed by the globes of the street lights of the Kaufingerstrasse.

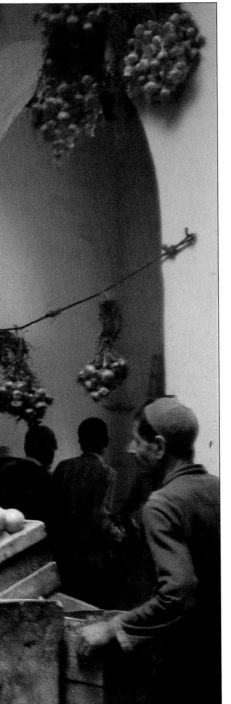

Left:
There are many triangles as well as circles in this picture of the indoor market in Djerba, Tunisia. However the eye is drawn to the main figure off-centre because he is bathed in light – and also unlike all the other people in the picture we can see his face.

A CHECKLIST FOR COMPOSITION

■ Analyze pictures by drawing lines on them which link the lighter areas. Usually the lines on the more interesting photos will make triangles or circles, or a series of them.

■ Not all pictures need be the same shape – some are best upright, some horizontal or even square. Crop or cut them if necessary to get the best shape to frame the subject.

■ The area of most interest in a picture is not always in the centre – it is often placed two thirds up the height of the frame where the eye seems to expect it.

■ Lines, such as pathways or shadows slanting across the frame, can be used to draw attention to the area of most interest. Converging lines are more interesting than parallel ones; they suggest more energy (they also form triangles). Curving lines also have more life in them than straight ones (they form ovals and circles).

■ Other ways of drawing attention to the subject are to put it into the lightest area of the frame, to isolate it from other objects or to control the focus so that the subject is the only sharp part of the picture.

■ An illusion of depth can be pleasing in some pictures. To suggest it, use objects in the foreground and background which suggest a sense of scale. Let lines in the picture run from the camera to the distance, rather than across the frame.

■ Make sure objects like lamp-posts, plants or trees are not immediately behind the head or ears of anyone in a picture – it will look as if they are growing from them! Move either the camera or the subject to avoid this.

■ On close-up portraits, if someone is shown looking left or right it is best not to place their head in the centre of the frame. Have a space or 'looking room' on the side of the frame the person is looking towards or the picture will seem cramped.

■ If the face is not the lightest area, try to position dark areas behind the head and light areas in front of it. Move the subject or the camera to achieve this.

THE TOOLS YOU CAN BUY

CAMERAS –
WHAT THEY CAN DO

Long gone are the days when photography was all calculation and chemistry. Technology has given us cameras which can take away the awkwardness of loading a film, the guesswork from exposure and the uncertainty of focusing. They have also given us a multiplicity of features, facilities, modes and display panels. With today's cameras the problem is not so much how much automation they offer but is it helpful? Is it needed all the time or only occasionally? And can you choose when to use it? As you will find, much of this book tells you about switching off the automation and circumventing the systems. There is a real

danger that if you let it, the highly automated camera will take good technical pictures – that is, accurately exposed and sharply focused – but reflecting no personal view or character.

To help you decide what you want from a camera we will look at a list of their possible facilities, starting with the basic functions.

Cameras keep your film safely in the dark, only allowing in the light to create the picture when you press the shutter. Various winding methods are used to move the film along the back of the camera body so that when you decide to take a picture – opening and closing the shutter, letting in the light through a controlled aperture and focusing it by the lens – only an exact portion of the film is exposed to the light.

Left:

A focal plane (or roller blind) shutter. When the shutter is released the two blinds travel across the back of the camera close to the film. Adjusting the gap between them controls the exposure time, the larger the gap the slower the shutter speed.

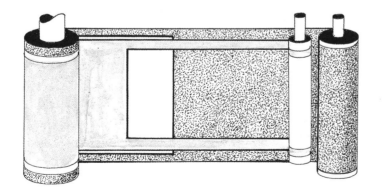
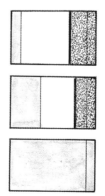

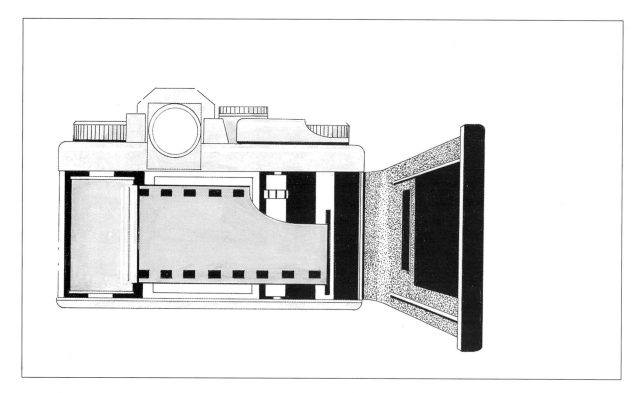

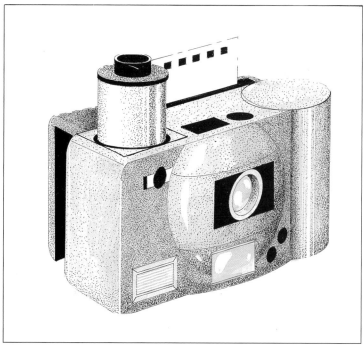

Loading your camera with film should be done away from bright sunlight. First drop the cassette container into its position. Next pull out a few inches of the unexposed film until it is stretched over the shutter and the sprocket holes are held by the cogs. Ensure that the film is in the slot on this spindle and is gripped as you turn on the winder. Close the back completely and advance the film to the first frame. Don't be intimidated by the machinery and don't rush.

When the film is finished rewind it until there is no tension and you are sure that it is safely back inside its cassette, ensuring that you cannot accidentally re-use it. Open the back and remove it.

Some manufacturers have invented simpler ways to load their cameras. With this system you pull out a length of film from the cassette. You then drop the stretched length of film and cassette into a slot, close the back and let the winding mechanism take over.

FILM LOADING, UNLOADING AND WINDING has to be done manually in the simplest cameras. But in a wide range of cameras loading may be semi-automatic, while motorized loading automatically advances the newly loaded film to the first frame. Other functions, such as the Advance (moving the film on after a picture has been taken) and the Rewind (moving the finished, exposed film back into its container), may be automatic as well. Whether your winding system is automatic or manual, there is likely to be a double exposure prevention. This means that after you have pressed the shutter you will not be able to do so again until the film is advanced to the next space. Motorized Winding usually exposes and winds one frame per second; advanced models may take up to six frames a second. A few cameras have a winding system which advances the film to the end when it has been loaded and then rewinds the exposed film frames into the container as they are taken. In this way if the camera is accidentally opened only the unused film is spoilt.

Most SHUTTERS are capable of opening and closing at a variety of speeds to cope with a wide range of light and movement conditions. Usually the speeds range downward in regular intervals from 1/1000th of a second to a quarter, a half and, the slowest, one second. The longer the shutter is open the more light it lets in – useful for evening or night shots. The shorter the shutter speed the less light is let in but faster movements are captured – useful for sports and animal pictures.

There are also some special shutter settings. Most cameras have a setting marked B (Bulb or Brief); this allows you to open and close the shutter for the time you choose. Other settings may open the shutter for a fraction of a second and fire off a flashlight at the same time. There is also a control called a Self-Timer which delays the release of the shutter button for about eight seconds, enabling you to rush around and be in the photo too. Dual and multi-frame self-timers enable you to take two or four shots in succession with one push of the shutter release.

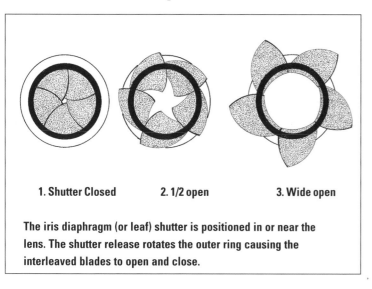

1. Shutter Closed	2. 1/2 open	3. Wide open

The iris diaphragm (or leaf) shutter is positioned in or near the lens. The shutter release rotates the outer ring causing the interleaved blades to open and close.

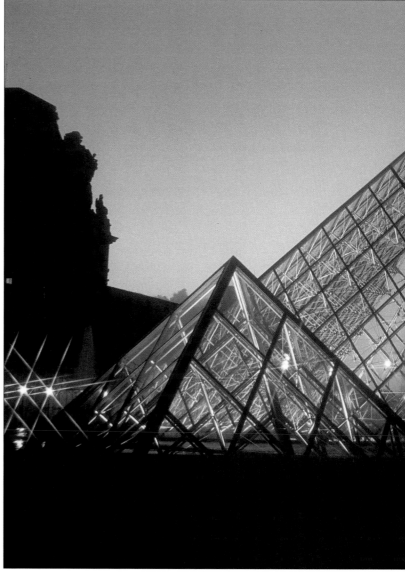

Above:
Slow shutter speeds are the only way you can capture the magic of nightime scenes.
(Pyramide of the Louvre, Paris)

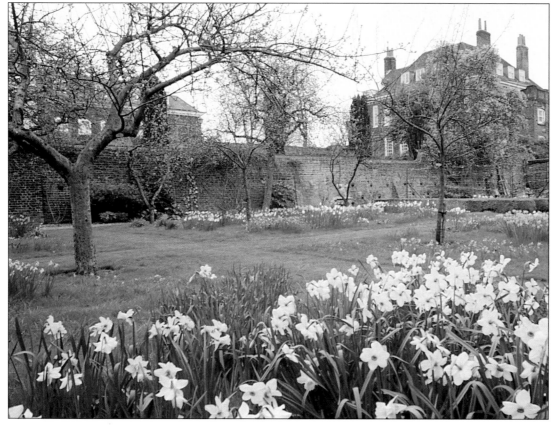

Left:
A narrow aperture giving great depth of focus was used to keep all this picture sharp, from the flowers in the foreground to the house in the background.
(Fenton House, Hampstead, London)

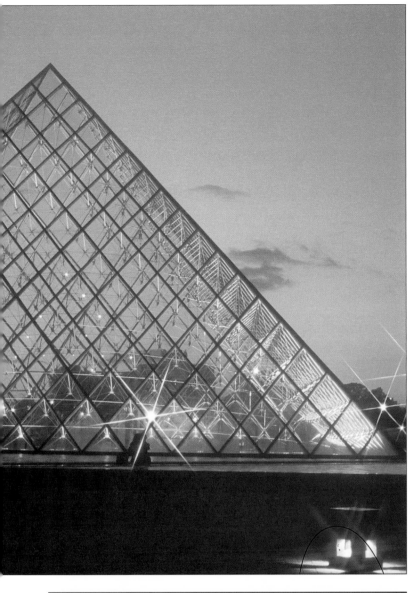

The APERTURE is a variable sized hole which can open and close to control the amount of light that passes through the lens onto the film. This has an effect on the focus, or depth of field. When the aperture is open to its widest (which is also the size of the lens) there is little depth of focus. This means that at whatever distance you focus there will be very little that is sharp in front and behind that point. The closer the camera is to the subject the more apprent this is as things in the background will be very blurred. Closed to its smallest the aperture gives great depth of field, meaning that objects will appear in sharp focus from near the camera to the far distance. Apertures are given an 'f' number which relates to the size of the LENS. Small numbers (f1.8 or f2) let in most light – high numbers (f16 or f22), the least.

f2.8		
f5.6		
f11		

This aperture system of interleaved plates shows the difference between widest and narrowest apertures – open to f 2.8, to f 5.6 and closed to f 22. On the bar chart the dark line represents the focussed subject. Notice how the depth of focus increases disproportionately behind the subject as you stop down (close the aperture).

f11 f5.6 f2.8

Left:
A wide aperture giving shallow focus was used to make the shape of this lamp stand out from its stately home background.
(Osterley House, West London)

Below
A fast shutter speed of 1/250 second was essential for this shot of seagulls to 'freeze' their movements.

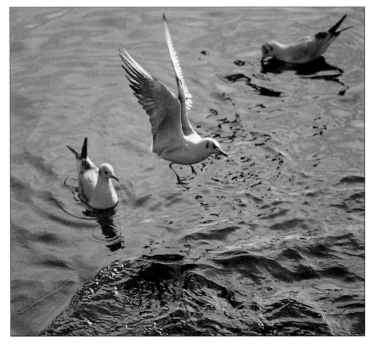

The LENS comprises one or more discs of glass that focus the light from the scene you wish to photograph onto the film. The ring holding the lens is usually marked with numbers which give you useful information. First it has an f number (a 2.8 lens may be marked f2.8 or 1:2.8), indicating its widest aperture.

Beware – cheaper lenses may not give sharp results operated below f5.6, even when properly focused.

The second lens-holder marking is a number in millimetres, indicating the focal length. This tells you how much of a scene it will see. For cameras using 35mm film the 50mm lens (the standard lens fitted to most 35mm cameras) will give you a picture approximating to what the human eye sees. If you want to see more you will need a wide-angle lens, the most usual being 24mm, 28mm and 35mm. Telephoto lenses bring distant objects closer ; they range from 80mm, 100mm and above. Wide-angle lenses give a great depth of focus, while telephotos have very shallow focus.

These focal length numbers are especially relevant if you want a zoom lens. A zooms enables you to vary what the camera sees without having to change the lens (or the camera!). It is most common to find cameras with zoom lenses which range from 35mm to 70mm.

Lenses may be either fixed focus (everything beyond a certain distance from the camera will be sharp) or variable focus (the lens can be adjusted to focus on specific objects). Focusing may be either manual or AF (automatic).

Beware – most AF cameras focus on whatever is in the centre of the frame.

Only the more sophisticated camera models have the ability to sense that your subject could be off-centre and focus accordingly. Failing this, you will need another facility called Focus Lock. With this you point the camera so that the object or person you want to be sharp is in the centre of the frame. You then focus and thereafter fix that focus (usually with a slight pressure on the shutter release), so that it will remain unchanged wherever you subsequently aim the camera.

Below left:
A glass fronted building taken without a filter. You cannot see through the glass and the reflection of the sky has affected the automatic exposure making the picture dark.

Below:
The same shot with polarizing filter. Almost all the reflection has gone here allowing you to see through the glass.

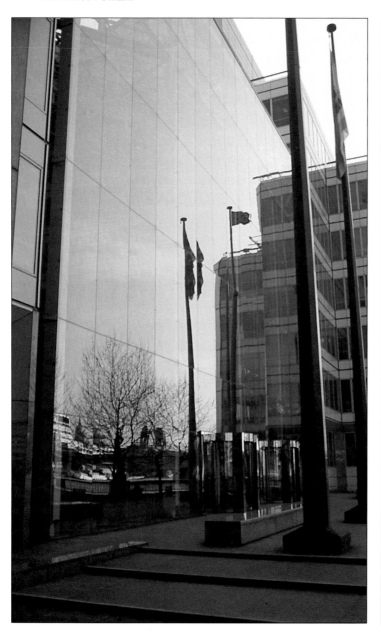

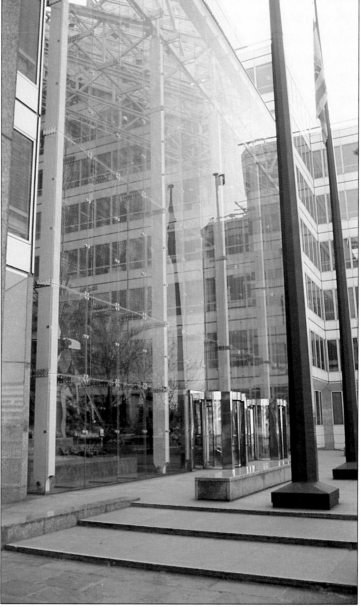

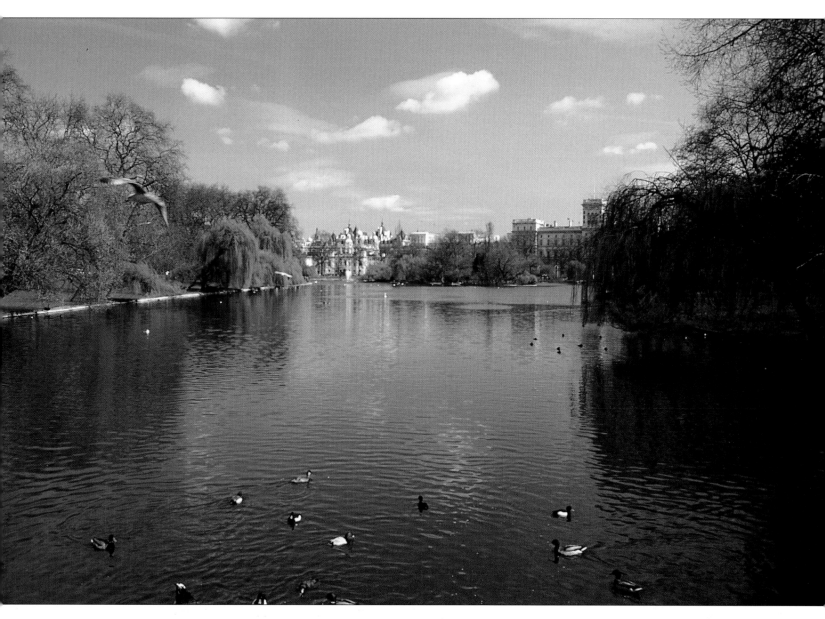

Above:
The reach of a fairly typical zoom lens is illustrated by these pictures of London's Whitehall seen from St James' Park. This wide angle is the lens at 28mm.

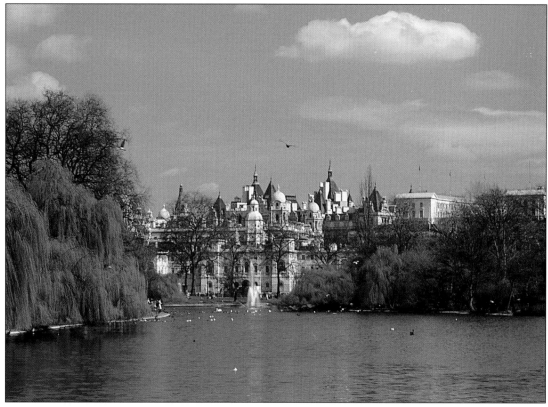

Right:
The closer picture taken from exactly the same position is the lens at 100mm.

EXPOSURE

To make sure that you achieve a good photographic image four pieces of information are needed to calculate the correct amount of light required as well as the length of time the film should be exposed to that light.

1 The sensitivity of the film, that is the film speed (rated by an ISO number).
2 The amount of light reflected from the subject of your picture needs to be measured (also called metering).
3 The shutter speed must be decided.
4 The aperture must be decided.

Happily, at least three of those calculations can be done by your camera.

1 The film's speed number is printed on the packing. On some cameras you set a dial pointer to that number; others use DX Coding. This means that the speed number is coded on the container and when it is loaded the camera reads it and adjusts itself automatically.

Beware – some cameras cannot adjust for the slowest and fastest films.

2. The majority of cameras have Auto-Exposure, which means they can read the strength of the light in your intended picture and automatically set either the shutter speed or aperture (relative to the film speed). If the camera enables you to set the aperture and the camera's auto-exposure system sets the shutter speed, the system is called Aperture Priority. Alternatively, if you can set the shutter speed (less common) and the camera sets the aperture, the auto-exposure system is called Shutter Priority.

Beware, auto-exposure systems are unable to cope with every situation! Most read the centre area. If that area is very light and the rest of the picture dark it will under-expose the film, making your final picture very dark. Conversely, if the area assessed is very dark and the rest of the picture bright, the camera will over-expose the film resulting in an over-bright, burned-out picture. A few sophisticated cameras offer a choice of metering methods – reading a small centre spot, reading the central area or sampling areas of the picture and arriving at an averaged exposure for the whole frame.

There is an additional control – Backlight Compensation – on some cameras. This lets in a little more light than the auto exposure has allowed and is usually enough to correct for pictures where the background is much brighter than the faces – light coming from behind the subject or snow scenes.
(*See also* section on Processing).

3 & 4 Apertures and shutter speeds always work together. A wide aperture and a slow shutter speed would let in too much light, resulting in an over-exposure (pictures too light); a small aperture with a fast shutter speed gives an under-exposure (pictures too dark). Balancing the two correctly gives combinations very suitable for certain types of picture. High shutter speeds with wide apertures are good for portraits or sports pictures – the shutter captures quick movements but the shallow focus can blur the background nicely so that your eyes can comfortably concentrate on the clearly focused person. Slow shutter speeds with narrow apertures give good results on still or slow moving subjects – landscapes with everything sharp from near the camera to the far distance or all the flowers in a wedding bouquet or garden group in sharp focus.

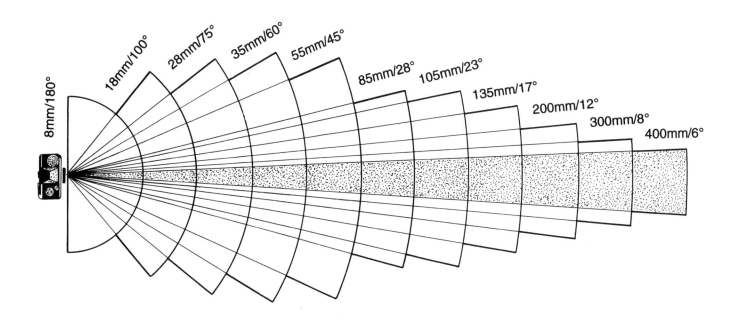

Lenses have their width of view marked as a focal length in millimetres. Fixed lenses see one angle only, zooms range through several. This illustration shows the corresponding angles for 35mm cameras.

EXTRA FEATURES

Panorama is a facility which creates a very wide picture by blocking off part of the normal frame area – suitable for subjects such as landscapes. Cameras with this facility either use an adaptor which must be inserted before loading the film and means the whole roll must then be shot in this format, or have a switchable mechanism that allows for different format shots to be taken on the same roll.

Beware – films containing mixed format shots may cost extra to process. Inform your processor before having the film developed.

Data Back is the facility that allows for the recording of certain information either on the roll or on a frame of your film. The Manual form usually prints a date only; the Quartz form offers an LCD display with clock facility, giving the option of recording both a time and a date.

TV Mode allows for pictures to be taken from the screen.

LCD Panels show which camera facilities are selected and operating – type of metering, exposure mode, flash, battery level, number of pictures taken, etc.

FLASH

Flash lights produce an incredibly bright light (almost equalling daylight) for an incredibly short time, up to 1/6000th of a second.

Built-in Flash, where the gun is either part of the body or pops up when switched on, works off the camera batteries and will light a subject up to four or five metres away from the camera. Usually a low-light indicator shows when you should switch the flash on.

Auto-Flash contains a sensor that fires it automatically when the light level would otherwise mean a slow shutter speed. Some cameras have further controls which enable you to switch this type of flash to Fill-in. This allows you to use the flash even in bright light, such as when the subject is shaded or the background is lighter than the subject's face.

Anytime Flash is the system which calculates the correct amount of light to use, balancing flash with daylight when necessary, and has all the automatic modes which additionally may be switched on or off. In other words it gives complete creative control.

Slow Flash or Auto-Flash with Slow Synch gives a slow shutter speed and fires the flash either just after the shutter has opened or before it closes. This lights the subject with the flash but the shutter stays open long enough to expose the background. It is useful for taking pictures of people at night without losing the background scenery. Although the flash will register the figures sharply, if the camera shakes the background will blur. To avoid this support the camera, or, if it is hand-held, steady yourself.

Cameras without built-in flash usually have connectors for separate flash guns. A hot-shoe bracket (usually on the top of the body) lets you fix on a dedicated type of flashgun which is controlled by the camera. Other cameras may have a 'Synch' or 'X' connector which allows for an external cable to be connected to the flash. This can then either be fixed to the camera or placed some distance away from it.

Some flashguns can be tilted backward or forward to direct the light more accurately. These guns enable you to use the bounced flash technique.
(*See* section Using Flash).

A useful device with any flash is a diffuser – either a material covering or a silvered surface which is placed in front of the light. Although it cuts down a little of the power, it softens the light, making shadows softer and more natural.

Anti Red-Eye is a system which prevents flashlight being reflected from people's eyes and showing in the picture as a curious, glowing red dot in the pupil

Beware – some flashlights produce an effect like the headlamp of a car – a brightly lit centre with a very visible falling-off of light towards the edge of the picture. This is especially noticeable on shots taken with wide angle lenses or zooms. Check when buying that the flashlight beam is wide enough for your lens, or that you can vary the spread as you change the width of your lens.

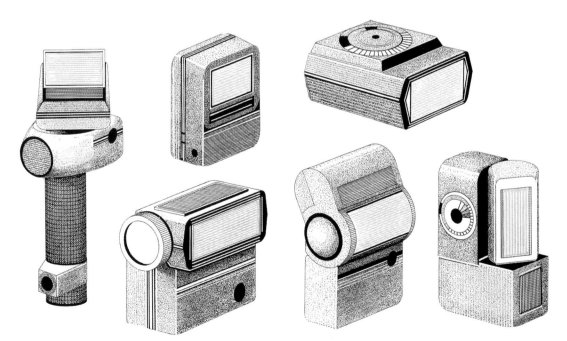

A wide variety of separate flashguns is available. More expensive camera models often have guns dedicated to functioning with them alone, the in-camera sensors connected to the flash control its intensity, matching the light to the subject. The diagram shows how some models can swivel to direct light in the directions you choose, making it easy to bounce the flash.

CAMERA TYPES

The Compact camera using 35mm film is the most popular type of camera with family photographers because it is small and easy to carry about. Depending on the facilities it offers it can be inexpensive and basic or automated, sophisticated and pricey.

Such 'point-and-shoot' cameras will remove much of the worry from taking photos. But there are two main disadvantages to them. Firstly, you cannot change the lens, so it is important that you buy a camera which has exactly the one you will need. Secondly, you cannot see exactly what the camera will photograph, because the viewfinder is separate from the taking lens, being either above or to one side of it. This problem of 'parallax' as it is called only makes difficulties when you want to photograph something closer than about one-and-a-half metres away from the camera. Usually the viewfinder has markings in it to help you overcome this slight limitation.

Extra Points to Consider When Buying A Compact

What type of lens does it have?
SINGLE – a lens with one focal length number, or TWIN – giving you a choice of a normal angle or a closer shot without moving the camera, or ZOOM – giving you a range of wide to close shots (eg 30-70mm).

What focal length number is the lens?
Will most of your pictures be wide angle family groups or pictures of buildings? Or will they be pictures of faces and details of small objects? Or will you need a zoom?

Does it have manual or automatic focusing?
If automatic, how many focusing steps are there? The more it has the sharper the image will be.

How close is the closest it will focus?
This is only important if you have small pets or objects which you will want to get close to, in which case you may need a Macro facility

What is the range of shutter speeds?
This is important for action photography.

Has it the DX film coding facility?
If it has, you should check the range. Some cameras can only recognize slow or medium sensitivity films; this will curtail the use of fast films for indoor and action shots.

If there is a Panorama facility – is it the adaptor or switch type?

Beware – some high priced Compacts have lots of facilities which you may never need or use. If you like the idea of everything automated then pay enough to be able to switch them off! Strange as it may seem, there will be times when too many automatic features prevent you from getting the picture you really want.

Single Lens Reflex cameras (SLRs) have lenses which can be changed giving the possibility of matching the differing types and qualities of lenses to the picture you want to take. The viewfinder enables you to see through the taking lens so that you frame your picture exactly. Their greater flexibility means that they can take almost any subject and can cope more easily with tricky light conditions.

However, to get the best from a SLR camera you should acquire some knowledge of photography. Prices start much higher than for basic Compacts– some four times the cost – but they are capable of far greater sophistication. They use 35mm or larger sizes of film.

There are various other types of cameras that use different sizes of film, but they tend not to be as popular as the ones using 35mm. Cameras using larger film sizes are mostly aimed at the professional user. Although they are capable of producing sharper and more subtly graded photographs, they are usually big and unwieldy to carry. At the smaller end of the film scale, there are a few cameras still using the small size 110 film. Their viewfinders are separate from the taking lens, so that they are usually the fixed focus type. They do not have the range of automatic features of the larger cameras. Also, because the film is a small size, the photographs cannot be enlarged so satisfactorily. Offsetting the disadvantages of their lower picture quality, however, 110 cameras are easy to load (the film comes enclosed in a cartridge) and convenient to carry in a pocket or handbag.

There are Disposable (or recyclable) cameras sold with the film ready loaded (usually ISO 400). These are cameras with one shutter speed (around 1/100th of a second) and a fixed focus lens; they are handed back complete to the processor when the film is used. Various versions, with Waterproof, Panoramic or Flash facilities, are available and they produce good results in many basic photo situations – good if you have forgotten to take a camera away with your or want to try underwater pictures.

There are also cameras of interest to people with special hobbies. There include Offroad or Sport cameras which are dust, sand and water resistant (as opposed to Underwater cameras which are waterproofed for diving and may have fixed or changeable lenses and a built-in flash. There are also the Instant cameras that produce prints in a few seconds and 3D or Stereo cameras that give realistic results at moderate prices. Finally, at the time of writing, there is also a Digital camera which records its images on a disc so that the pictures can be viewed on your personal computer.

FILMS - *COLOUR AND BLACK & WHITE; FAST & SLOW*

Any camera is capable of using a range of films so taking it to the shop to buy a film is only of limited help. All an assistant can tell from your particular camera is the size of film it uses and if it has the DX coding mechanism. The rest is up to you. Choosing a film means knowing how you want to use it. So what are the possibilities?

Film for taking pictures in colour comes in two basic type, – negative and transparency. Negative film is used for making prints; transparency for making slides Both types are made in a range of speeds or sensitivities.

Most people like colour prints because they are easy to look at and carry around. It is also easy to have either the whole or part of the picture enlarged for display [see section Showing

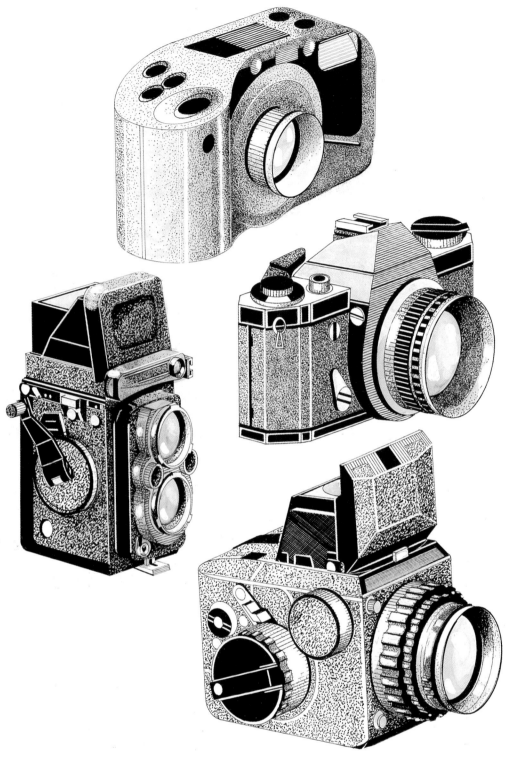

Types of cameras.

1. Compact. The most popular for its lightness and ease of use. The viewfinder is separate from the taking lens. This one has a zoom. All use 35mm size film.

2. Single Lens Reflex (SLR). This is popular with keen amateurs and professionals. The viewfinder and taking lens are combined. Usually it is available with a choice of interchangeable lenses. It uses 35 mm film.

3. Twin Lens Reflex. Used by amateurs and professionals. The viewfinder is above the taking lens and is attached to a removable plate. Interchangeable lenses are used. Uses 120 size film to produce 6x6 cm negatives.

4. Professional type SLR with interchangeable lenses. Uses large film sizes to produce negatives of 6x6 cms and upwards.

Different camera types offer advantages for differing photographic uses.

Your Pictures]. Another point in favour of print film is its exposure latitude. In other words, your exposure does not have to be 100 per cent accurate to get a good or even passable result. And, as Compact camera metering systems can be somewhat basic, this type of film is very suitable for getting acceptable results from them despite their various shortcomings. Although negative film goes through two processes to produce the finished print – developing the film followed by exposing and developing the print – it is generally a comparatively inexpensive medium to buy and process.

Transparency (or slide) film is capable of producing excellent, sharp images with wonderful colours, capturing nuances of light and shade that are often lost in paper prints. It is still the first choice for most professional work. Its disadvantage is that you need special equipment to see the finished picture –- either a magnifying viewer powered by batteries or a projector throwing the images onto a suitable wall or screen. A further limitation is that it requires exact exposure; only slight under- or over-exposure results in poor pictures. Slide films are made in two variations for different light: daylight and tungsten (or artificial light). Using daylight film with artificial light results in yellow pictures; tungsten film used in daylight means everything tends to haved a bluish hue. (*See* section on Filters, page 22)

Camera supports are very varied.

Mono- or Tripods usually have rubber feet, often retractable to reveal a metal spike for outdoor use.

Monopods are easy to pack away and useful for sports and action shots.

Small tripods pack easily and can be used on tables and ledges.

Full size tripods have telescopic legs, a rising centre column for extra height and may have braced legs for extra rigidity.

If you want to use a tripod both for high and very low shots check how far the legs will spread and still support your camera rigidly.

(Mono-) Tripod Heads.

RIGHT: A ball and socket allows you to fix the camera at almost any angle.

CENTRE: This ball and socket has a camera plate for firmer support.

LEFT: A Pan and Tilt head gives movement in two planes allowing great flexibility of camera angle. Suitable for heavier cameras.

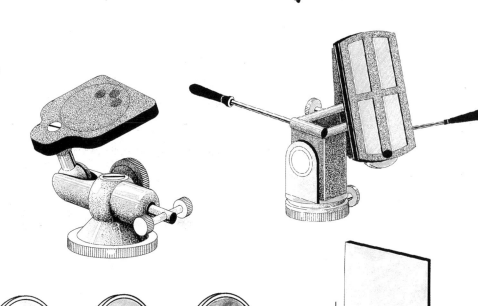

Filters.

Round ones screw into the lens.

This system uses a holder fixed around the lens into which you drop square filters.

Check: with some Compact cameras it may be difficult to fix filters, improvise fixing them with a substance like Blu-tack.

Some accessory equipment is useful to most photographers, but only buy to make it better and easier to take the sort of pictures you want.

Slide films intended for the amateur usually include the cost of processing in the purchase price and they will often be returned to you in a plastic holder or mount. If the film is intended for professional use, the cost of processing would be extra.

Slide film for amateurs is frequently given a treatment to protect it against extremes of temperature and humidity.

Black and white film is still popular with people who view photography as a creative hobby. It costs about the same as colour print film and is made by all the major film manufacturers. Most film laboratories will process it.

The sensitivity of a film is called its speed and it is rated with an International Standards Organisation (ISO) number. The higher the ISO number the more sensitive it is to light. Slow speed film (ISO 25 or 50) needs strong light – or slow shutter speeds – but is capable of recording very fine details. This is useful for still or slow moving subjects where detail and subtle

colour gradation are important. Medium speed films (ISO 100-200) are the most used as they are capable of giving good detail in many ordinary daylight conditions.They are suitable for a wide range of holiday, garden and family situations where movement is not fast. The fastest films (ISO 400, 800, 1600 and above) need the least light and allow the fastest shutter speeds; they are good for sports and action but you may have to sacrifice some sharpness and colour gradation.

Older film speed ratings, such as ASA (American Standards Association) and DIN (Deutsche Industrie Norm, the German Standards system), are still marked on many films.

ACCESSORY EQUIPMENT TO CONSIDER

Most family photographers choose not to complicate life by carrying extra pieces of equipment with their camera, but there are a few things which can help to give better results in special circumstances. It is not always necessary to buy these, especially as you may only need to use them once or twice. Borrowing from a friend is a possibility or some may be available for hire.

Lens Hood

This short, black, circular or square tube is attached to the lens to prevent stray light shining into it thereby affecting pictures. It is useful if the sun is low or when shooting towards a light source. (The adverse effects show in photos as flare – streaks of light at the edge of the frame – or as a hazy area or a reduction of sharpness.) Lens hoods are made of plastic or rubber and are not a major financial outlay. They cannot be attached to all cameras, though, so check with your photographic retailer.

Separate Flashgun *[See also Chapter on Flash]*

If the flash on your camera only gives good results on close-up subjects, it may be useful to use a separate one where more power is needed. You may wish to use the Bounce or Diffused Flash techniques for portraits or groups. There may be occasions where you would want a light to one side of the camera or even to 'paint' with flash (see page xx).

Tripods

This three-legged stand is invaluable on many occasions – for sports and action pictures, any time when the shutter speed is slow, when you want your hands free to for other controls, or if you do not have a steady hand. A tripod generally comes in two parts – the legs, which are telescopic but are made in many lengths, and the head which is the device that allows the camera to be fixed at any angle. The simplest head is a ball-and-socket type which twists to lock into position. Others, called pan-and-tilt, have a small platform for the camera and allow separate control of sideways and forward/backward movements.

To be sure that the least possible vibration affects your camera on the tripod you can press the shutter without touching the camera by using a **Cable Release**. This thin flexible tube has a cable running through its centre. It screws around the shutter button and releases it by pressing the cable. It is also made with a lock, usually a small screw which holds the cable in the open position, leaving your hands free during very long exposures.

For some situations you may be able to use an alternative to a tripod – the one-legged Monopod.

Check that the tripod screw will fit your particular camera and that the whole tripod assembly will suport the weight of your camera and be suitably rigid, especially on uneven ground.

Filters

Filters are pieces of gelatin or glass which change the light passing through them. They can be used for many creative and fancy effects but you may wish to consider using one or two for their corrective abilities. The best quality ones are glass mounted in a ring holder which screw into the lens holder. Another system uses a frame fixed to the lens into which filters are fitted.

Experiment with these filters for colour film:

Ultra Violet	Helps give clarity to the distance in landscapes; removes blue cast in high locations.
Polaroid	Makes skies more blue, reduces glare, controls or polarizes reflections. Very useful for shooting objects behind glass.
Wratten No. 80B	Stops scenes lit by artificial light looking too yellow.
81A and 81B	Warms the colours in a photo, useful on overcast, grey days.
1A	Can improve landscapes by improving contrasts, especially between sky and land or sea.

Beware – most filters reduce the light going through them. If your camera does not have through-the-lens metering (TTL) you will need to cover the light sensor with a piece of the same filter you are using over the lens or the picture could be very under-exposed.

TIPS TO TRY

■ You don't have to buy expensive filters and holders. If you just want to find out if filters could be of use to you buy small pieces of gelatin filter from the professional photo shops, cut them to the size of your lens and fix them in position with Blu-tack.

■ For a soft-focus portrait stretch clingfilm over the lens.

■ For a dramatic sky filter use a pink, brown or yellow toffee paper over the sky area of your picture.

CARE OF YOUR CAMERA

Cameras have never been more sophisticated and yet easier to use. But no one has yet invented a camera which will continue to give good results despite dirt and neglect. The best lens cannot produce sharp pictures through dust and finger marks, the most accurate shutter will become unreliable with fluff in the works and the most expensive motorwind can jam with bits of sand or broken off film inside the camera. As many pictures are spoiled by dirty cameras as by lack of photographic techniques.

Camera First Aid Kit:

Essential	A blower brush and an anti-static cloth
Important	A camel hair brush and/or a soft paint brush
Useful	Lens cleaning fluid and tissues.

Routine maintenance

• Clean gently, taking particular care with all glass surfaces and inside mechanisms. Do not lubricate.

Outside

• Use blower brush to remove dust from the body, all moving parts and especially the rear viewfinder.
• Clean lens with the blower brush and anti-static cloth using circular motion. (Do not use spectacle cleaning fluid or apply fluid directly to lens.)
• Use the cloth to clean the front viewfinder, auto-focus and metering windows.

Inside

• Make sure there is no film in the camera before opening it!
• Do not push or knock the shutter blind.
• Do not touch the mirror in SLR cameras.
• Use the blower to move any dust, fluff or grit.
• Check that there are no bits of broken film anywhere.
• Use the brush for a final clean, especially in the channels where the back closes.

General Care

• Make a habit of replacing the lens cap after using the camera.
• Try to keep the camera covered when not in use.
• Do not leave the camera in the glove compartment, boot or back window of a car; heat ruins cameras and films.
• Do not leave the camera uncovered on the beach; sand, dust and salt sea air are other photographic enemies!
• Store film in a fridge, both before you use it and after if necessary, but get it to the processor as soon as you can.
• Cold runs down batteries fast. When taking pictures in cold weather keep the camera warm betwen shots by placing it under your coat and take a set of spare batteries with you when you are out and about.

If you value your camera and are in any doubt about cleaning it or its efficient working, consult a professional camera repairer or dealer.

Protect your camera and attachments, as well as keeping them in one place, with a special bag or pouch. Buying larger than your current needs gives you room to expand and space for all those travelling extras, guidebooks, passports and tickets.

Remove (or obliterate) all brand name tags from bags and covers, they only alert thieves to possible pickings.

HOLDING THE CAMERA

O NE OF THE MOST important technical lessons in photography is how to hold the camera. Held awkwardly, your pictures will always have obvious defects. Poorly composed, blurred or badly focused and exposed pictures can all be the results of holding the camera incorrectly.

Always be comfortable and relaxed. If you are tense when you hold a camera you are more likely to make exaggerated or involuntary movements at the moment of pressing the shutter, spoiling the composition and probably blurring it.

Always hold the camera with both hands. Many cameras have grip pads as guides. Keep your hands in such a position that the index finger is always hovering over the shutter button, ready for action. The weight of the camera can be supported by the other hand, either cradling the lens in it or resting the lens between thumb and forefinger for models which have manual focus. This hand should be used to steady the camera whether it is heavy or light.

Check that no finger or part of your hand is in the way of the viewfinder, autofocus, metering windows or flash. This is often a problem especially when the camera is turned to take upright pictures.

Check, too, that nothing is hanging down from the camera or its case, causing an obstruction.

Pay attention to your arms and legs. Stand with your feet apart, the weight of your body centred. Tuck in your elbows and hold the camera closely against your face so that you can see comfortably into the viewfinder.

The viewfinder technique is particularly important. Ensure that your eye is close enough to see all four edges of the front window picture frame and that the image is clear – neither fuzzy nor misting up.

Finally, when you are ready to shoot, push or squeeze the shutter release smoothly and gently. Stabbing or jabbing at it will move the camera and cause camera shake and blurry pictures. Some people advise holding your breath while you release the shutter; in fact, this is more likely to cause tension, so during all your preparation just make sure that you are still breathing – just gently and normally!

Most cameras have a warning to tell you when the light level is low. In theory this means that the shutter speeds are so slow that you should use a tripod to get clear pictures. But, with shutter speeds down to 1/15 of a second, you may get a reasonable picture if you can simply steady your arms or body.

TIPS TO TRY

■ Put your elbows on a table, or kneel on one knee and put one elbow on the other knee.

■ Put a shoulder (or lean back) against a wall, tree or pillar.

■ Try putting the camera on a ledge, heavy books or the floor (if the position gives you a good angle). But if you do this, keep the camera flat on its base; trying to hold it pointing up or down, leaned on its edge, never works.

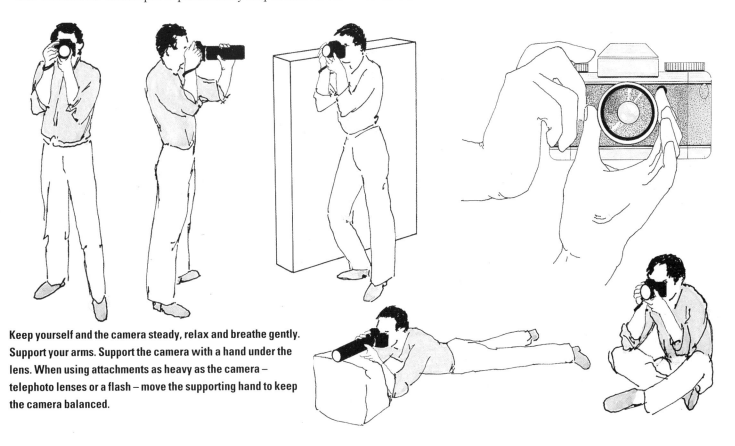

Keep yourself and the camera steady, relax and breathe gently. Support your arms. Support the camera with a hand under the lens. When using attachments as heavy as the camera – telephoto lenses or a flash – move the supporting hand to keep the camera balanced.

USING FLASH

ALMOST EVERY CAMERA on sale today comes equipped with a flash – even the Disposable ones. The power of the light from each model is different but its effectiveness always depends on the speed of the film in the camera.

To use the flash effectively you must know its shooting range for your camera. This is a list of the maximum distances to which your flash will light properly for each of the different film speeds. It may be in the instructions; if not ask your camera dealer for the information.

Flashlights help to improve pictures in many ways. They give you a light where there is none – at night, out of doors or where there is no electricity supply. They replace portable lights or reflectors. They replace the need for tripods, by giving a strong light and allowing for shorter shutter speeds. You can point and shoot without worryin many cases; however, your pictures will benefit if you can master a few techniques.

Avoid using the direct flash; the clear harsh beam of light (making harsh shadows) can be so much brighter than other light that its headlight effect can destroy all atmosphere.

Diffuse the flash with the cloth or reflector devices supplied with it, or put thin tissue or white cloth over the lamp.

If you have a flash that will tilt and shine upwards, use the 'bounce' technique. This means that the flash is turned to shine onto the ceiling which bounces or reflects the light down onto the subject, producing a soft, scattered light with soft shadows. For this to work successfully the ceiling must not be high (the total distance from flash to ceiling and down to subject must be well within your maximum flash distance) and it must be white (other colours could absorb too much of the flashlight or reflect their own colour onto your subjects). Avoid pointing the flash straight up, otherwise the light will bounce straight down again,

causing dark bags under people's eyes. Pointing the flash up and forward makes the light fall from the front of faces and look more natural. Calculate this angle carefully or the light might miss people altogether and fall behind the subject.

Use bounce flash off white walls as well. By turning the camera sideways, both the upright picture framing and the soft side-lighting can create flattering family portraits.

Use the fill-in flash to reveal details in otherwise dark shadows when the sun is bright and harsh. Use it , too, for portraits of people in the shade or when bright sunlight might make people squint as they look into the camera. Ask them to turn their faces away from the sun and light with fill-in flash.

Above:
Using flash both illuminated the subject's face and also captured the snowflakes falling.

Left:
Using direct flash was the only way to snatch this 'humorous' portrait; there was insufficient natural light to use either to use as the only light source or with fill-in flash.

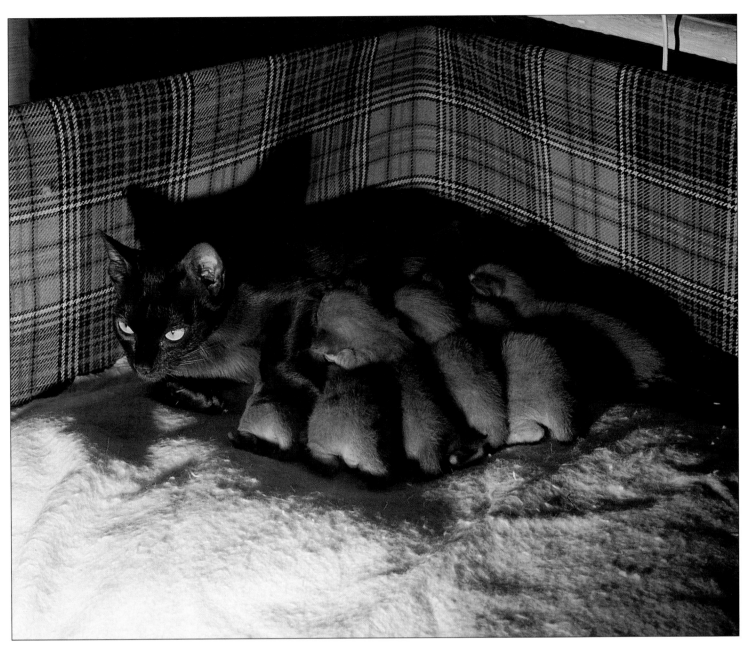

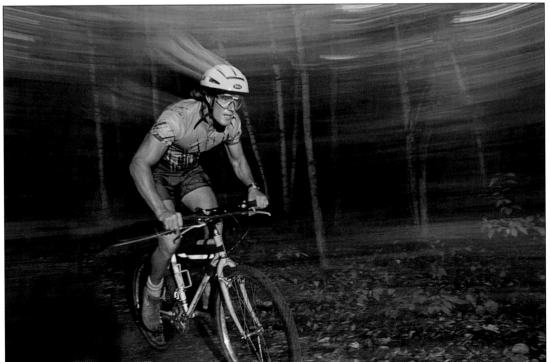

Above:

Animals often choose dark places to rest and would be disturbed by bright lamps. Rarely, however, do they seem to be disturbed by flash. A separate flash, used off the camera has made it easier to see the mother cat and her newly born kittens.

Left:

Action frozen by the flash – the intense, brief light has frozen the cyclist's movement. But using fill-in flash meant that the shutter remained open longer than the flash letting in the daylight which lit the background. This is blurred because the camera panned with the subject.

Use flash to freeze very fast actions. Its high power and extremely brief duration can capture an action as effectively as short shutter speeds [see Sport and Action, page xx].

If you have a flashgun that is separate from your camera you can 'paint' with the flash. This is a useful technique for taking shots of large areas which may be darkened or are extremely dimly lit. Here is how you do it.

• Support the camera or use a tripod.
• Set an aperture which would give you a picture from the existing light with a shutter speed of about one minute.
• Consulting the flash instructions, find the subject to flash distance for that aperture.
• Set the shutter to B and use a locking cable (or a friend) to hold the shutter open for the necessary time.
• You then have about one minute to walk around firing the flash (at the correct distance) to light the individual areas of the room. You may want to light it evenly or choose to feature specific areas. High ceilings may need two flashes. Keep out of the picture yourself if you can; if not, it helps to wear dark clothes. Be sure not to get yourself between the light and the camera.

TAKE CARE

Keep your subject within the maximum distance for your flash power and film speed. Most flash is useless if you are halfway back in an auditorium or even from the front rows of many sports arenas and swimming pools. Apart from the wasted cost of film and processing, your camera batteries will drain rapidly.

If you use flash for photographing groups make sure that no one person is much nearer to the camera or further from it than the others, otherwise the closer people will be bleached out (overlit) and the back ones in gloom. To overcome the somewhat boring effect of people in a straight line parallel to the camera, group them in depth and try using bounce flash.

Using either direct or diffused flash, check that you have no shiny surfaces in the shot capable of reflecting your flash back into the camera. Mirrors, windows, glass door panels, even bright vases and ornaments are all capable of spoiling your pictures in this way.

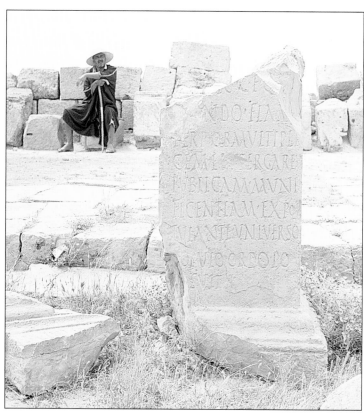

Above:

The photographer wanted an off-centre area (the lettering on the stone) to be in focus in this atmospheric shot of the ancient Roman site at Gighti in Tunisia, a problem for most AF systems.

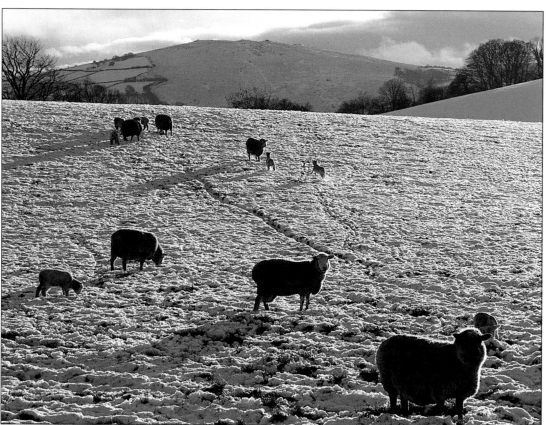

Left:

A problem shot for automatic cameras. Both the snow and the angle of the light in this Dartmoor winter scene could result in incorrect exposure unless spot metering was used or some exposure compensation made.

CHEATING THE SYSTEMS

THERE ARE ALL sorts of photographic situations (many mentioned in this book) with which camera automatic systems cannot cope very well. These problems are often made worse if there is no override and you cannot switch the system off to control the particular function manually. Living with the convenience of automatic exposure metering, focusing and flash also means learning how to cheat the systems. Here are some tips, twists and alternative approaches.

EXPOSURE

PROBLEM You are shooting in a situation in which you know the auto-meter will underexpose the pictures (eg, snow scenes or portraits against the sky). You need either an accurate exposure for faces, or you must increase the exposure by two stops.

SOLUTION If you have it, use the spot meter system where the meter reads the light only in a small area . This is indicated by a small spot in the viewfinder. Put the spot over the subject and push the shutter button gently, part-way, to lock the exposure. Holding the exposure locked, reframe and take the picture.

SOLUTION. Use the exposure compensation mode. This either increases or decreases exposure by two f stops which can be selected in a series of graduated steps.

SOLUTION. Use the backlight button. This opens up the aperture by about two f stops.

SOLUTION. *Cheat the system*; reset the film speed button until you see the display reading the extra two f stops you need. (**Do not forget** to reset the film speed when you want to return to accurate auto exposure.)

PROBLEM. You need to use a slow shutter speed. Your camera is supported, maybe on a tripod, but you have no cable release. You want to avoid the camera shake you could get if you released the shutter manually.

SOLUTION. Release the shutter with the self-timer.

FOCUS

PROBLEM You have a well composed picture but the subject is just off-centre or at the side of the frame. The auto-focus will only focus on the background, not on the subject.

SOLUTION. Your camera AF system will only read the centre area of what is in the viewfinder. *Cheat the system*; use the focus lock facility. Put the subject in the centre of the viewfinder, press the shutter part-way which will hold the focus and reframe the picture. Push the shutter button down completely to take it.

PROBLEM The subject you wish to take is behind glass. The AF system will not focus through it.

SOLUTION *Cheat the system*; use the infinity setting. This is intended for focusing on faraway subjects, such as mountains, but it enables you to shoot through glass. (Check your camera instructions to see if this setting will give sharp pictures when the object is close, such as a small object in a glass case.)

FLASH

It is not always necessary to use the full power of a flash – its light is harsh and may produce hard shadows. Its power can overcome existing light destroying atmosphere.

PROBLEM The flash on your camera cannot be turned off. You want to use the existing day or room light but the light level is low and the indicator shows that the flash will come on.

SOLUTION If the flash indicator goes on your camera system is indicating that the shutter speed without flash would be very slow giving blurred pictures from camera shake. Avoid camera shake by supporting the camera (see section: Holding the Camera) and then CHEAT THE SYSTEM by covering the flash.

PROBLEM The indicator tells you that the flash will operate. You need the light but you do not want flash hardness.

SOLUTION You need to diffuse the flash. *Cheat the system*; cover the light with a thin tissue or handkerchief.

PROBLEM You want to take a portrait against the sun and you do not have (or want to use) the exposure compensation facility, nor do you have the fill-in flash facility.

SOLUTION Switch on flash and use diffused, as in previous solution.

DISPLAYING YOUR PICTURES

MUCH OF OUR personal and family history is captured quite effortlessly and casually by the photos we take. Its value as a record of where time has been spent, even who we are, is often overlooked or only realized later in life. So often a crumpled or faded picture completes a partly remembered occasion. And often, too, we want to have a new copy of the photo – but what has happened to the negative? For people who have a strong sense of personal history and for those who just like to re-live and share some fun times through their photos there are an increasing number of ways to protect and display them.

You can have enlarged prints made from negatives for framing or completely filling a page of an album. Or they can be blown up to poster sizes and put on to canvas. You can have place mats and coasters or jigsaws and greetings cards made from photos. You can have tee-shirts and calendars personalized by the addition of your favourite picture and if you fancy a real 'mug-shot' you can have your portrait put on pottery!

The prints you get back from the processor have already been enlarged and may be perfectly satisfactory for an album. But sooner or later there will be a picture that cries out to be made even bigger to display more publicly. Machine printing is the cheapest way to have this done but it has limitations. The development will be automatically controlled and it will receive only a limited amount of colour correction. The whole negative has to be enlarged – not just the section you would like. Hand printing does allow you to choose a section for enlargement and the finished quality should be better. But the cost will be more.

Be very clear in the instructions you give to the processor about print size, the section to be enlarged, colour balance, type of paper and so on. Then you will be able to check for sure that the results are as you had requested.

Above:

A wide variety of albums and frames are on sale to display your photographs.

Left:

How far back do your family pictures go? Could you make up a photographic family tree?

Right:

Although prints are the most popular photo medium some people like to display slides as well.

ALBUMS

These are available with various sized pages. Some have plain pages to which you stick corner pieces to hold the prints in place; others have self-adhesive pages, but allow prints to be peeled off when you want to move them. Slip-in albums are pages of plastic pockets, usually all of the same size.

Remember that you may need your precious negatives for making prints in the future sothey need to be kept dry and dust free in the meantime. They are easily protected if you leave them in the plastic strips from the processor but there are inexpensive albums for storing negatives, too.

Plastic envelope-type albums store a lot of prints but their chief merit is probably that they constitute a good filing system. More creative satisfaction can generally be had with the traditional or self-adhesive albums.

Make a story from your snaps – a holiday, your view of a wedding, how you saw a particular outing. Add to the story with such extras as invitations, entry tickets, menus, maps and postcards. You may also want to add captions to remind yourself about dates, names and places.

Edit your prints, rejecting some; seldom will you need them all. Some will be poor quality, some will be similar and some will overload the story by adding too much detail.

Change the shape of some pictures by cropping or cutting them. Some compositions can be improved or will benefit by cutting out superfluous or unwanted details.

Compose each page so as to avoid endless regular rows of prints. Albums with large pages give more scope for this.

FRAMES

There is a wide selection of picture frames readily available from shops today at a good range of prices. If your processor normally supplies prints in a large size, you could fill a corner or even a wall with satisfying images very economically.

Bear in mind that prints framed with a border tend tolook much bigger. Choose the border colour carefully to show off the picture better.

When choosing a frame colour take into account the surface it will hang on. Look for a contrast to help the photograph stand out from the wall.

Think about the pictures you group together, putting the best ones in one place; if they are too varied, they may cancel one another out, although if you have a theme you may be able to mix strong and less strong images to their mutual benefit.

TIPS TO TRY

To help you decide how much you could crop a print and also the final shape, cut two pieces of card into two wide L shapes. Slide them together over the picture until you find the most pleasing result.

VIEWING AND PROJECTING SLIDES

Slide processors usually return your film as separate frames, each one secured in a plastic mount and contained together in a useful storage box. However, if you have lots of slides to keep you may wish to purchase one of the many larger storage boxes that are quite widely available. Some have separate runners, cushioning the slide on a plastic mat; others have sliding trays which will load straight into a projector. Choose the system that works the best for you.

You can also buy mounts which hold slides between glass; this keeps them free from dust and protects from scratches and also the damage that warm or greasy fingers can do. However, they do not seem to keep their colours well over long periods.

Whatever way you choose to store your slides it is always a good idea, as with prints, to label the mount with at least a date, place or name. It can saves endless discussions later!

Viewing slides can be done with a battery-operated viewer – that is a small hand-held box which illuminates the slide behind a magnifying glass. You will see your pictures to better advantage, however, if you use a projector, making a show of them by throwing the images onto a white wall. Projectors come in a variety of sizes and prices; with the simplest you must change each slide, while more sophisticated ones take trays of slides and move each one on automatically by remote control.

If you have no suitable white wall you will need to invest in a screen. The cheapest have a matt surface and although they reflect light less well than the more expensive beaded ones they can be viewed from the side. The beaded ones are only intended to be viewed from directly in front.

FAMILY LIFE

THE LIFE of the family could never be completely contained in a photo album or you would have no time to be involved in it yourself! Just look at the list: weddings, the new baby and the Christening, birthday parties, moving house and all those anniversary celebrations. Then there are all the opportunities to show each stage of growth from youth to age – portraits and groups of partners, family and friends. You will find that the world of school and college needs a section all to itself.

Nobody wants to live their life looking through a camera lens, so it is important to decide on what is an important event to record. Pick up the camera just for that time, take what pictures you can and then go back to join in the fun of the occasion.

WEDDINGS

Weddings have their particularly important moments, such as when the bride arrives for the ceremony, when the couple exchange rings or garlands, when they embrace, when they sign the register, as they pose for the group photo, the cutting of the cake at the reception – perhaps also the speeches – and the moment they depart from the reception.

If it is your son or daughter who is getting married, or you are a close relative in some other way, it is unlikely that you would want to, or should, take the official photographs. Your closeness will mean that at most of the important photo moments you may have other duties. It is also the sort of task that needs experience and one in which the photographer does not have a second chance! But your close involvement does have

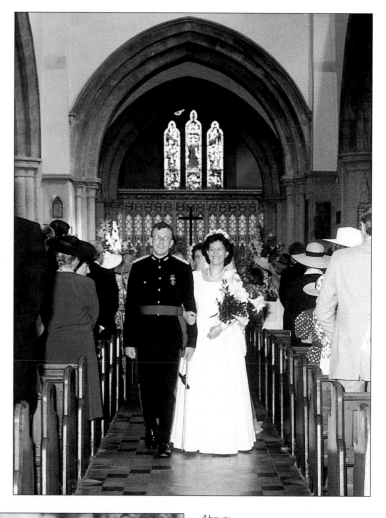

Above:

A wedding shot with the flash well balanced; the couple are not over-lit against the church interior.

Left:

Balance the formal moments with the informal when photographing weddings...

the advantage that you will know most of the people there so they will not be self-conscious with you. This often means that you are in the best position to take the informal, candid unofficial pictures. Incidentally, if there is an official photographer, it is courteous to make yourself known to him or her and to explain that you are taking informal, family photographs and not the sorrt of ones which he/she has been asked to take.

WEDDING MOMENTS TO LOOK FOR

- 'Backstage' shots of the preparations.
- The bride or groom's dash to arrive for the ceremony (before they appear calm and controlled in any official picture).
- Unexpected moments with the priest or registrar.
- The possible confusion as people get ready for the official group photo.
- The reactions of guests, both during the ceremony and while watching the group pose.
- And, since the official photographer may depart at this point until cake cutting time, you can cover the reception.
- Choose a time and ask the bride and groom to come away from the activity for a quiet, posed shot. It may be the only time of the day when they are not surrounded with people and are briefly able to relax.

As you are taking informal pictures your equipment should allow you to be fast and flexible.

• For the indoor shots load ISO 800 or 1000 film,;for outdoors (or if you have to load one film type for all occasions) use ISO 200, and be prepared to use flash indoors.

• Take at least one spare set of batteries, flash uses them up fast.

• Check your maximum flash distance; your camera may not have a powerful enough flash for use during the ceremony, unless you are able to get very close.

• Use available light as much as possible. If you have to use flash, diffuse it or use fill-in mode. At the reception you should also be able to use bounced flash.

• A wide angle lens is not really suitable for use at the ceremony except perhaps for a shot of the whole interior of the building. Nor is it of much use for informal candid photography outside or at a reception; if you want close-up shots you will find that you are intrusively close. If possible, use a zoom camera with a zoom up to 120mm, or, if it is a fixed lens, use one around 80mm-100mm. (The exception is when you know the reception will take place in fairly small-sized room, in which case you will need a lens of about 50mm.)

• Do not use a new or unfamiliar camera on such an occasion.

TIPS TO TRY

- Fill the viewfinder with your subjects, both close-ups and groups.
- With weddings in unfamiliar faiths, check the events and their order in advance.
- Check beforehand if the use of flash is possible during the ceremony.
- For an effective viewpoint at a church wedding, try taking pictures from the gallery (if there is one and you are granted permission).
- If you take shots outside a church, try to avoid the graveyard.
- Do not be tempted to take pictures over the official photographer's shoulder; it is the equivalent to stealing his or her work.
- At the reception, vary the viewpoint and shoot the activity from different levels, stand on a chair, even lie on the ground if it gets a good picture!
- Pose groups at the reception; take candid shots of ones and twos.
- If using flash at the reception, take your shots before it gets too smoky. Smoke cuts down the flash's effectiveness considerably.

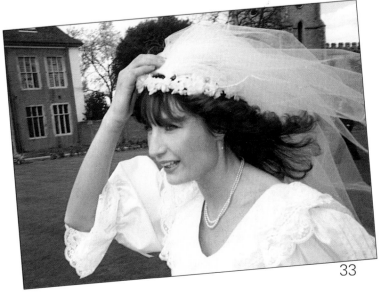

Left:
... or be humorous.

Below:
Informal moments, even hectic ones, should try to reflect the atmosphere of the event.

THE EARLY YEARS OF OUR LIVES

Newly arrived babies may be too small to fill the viewfinders of some cameras so photograph them either with mother or father, or in a cot with the surrounding items emphasizing their small size. For these very early photos use a high angle shot, looking down at the infant.

After a month or two it will be possible to lay the child on its stomach on the floor or on a cloth in an armchair. For either of these come down to the baby's level, photographing from the front or side.

Around the three-month time you will begin to get the first smiles and more mobile facial expressions. You can prop the child up and capture these early reactions whilst your partner, grandparents or friends whistle, sing, dance and generally try to catch the child's attention! Or you may prefer just to pose a picture of the infant looking over your partner's shoulder, either toward the camera or in profile.

Later the baby will explore stretching its limbs, becoming fascinated by its hands and the ability to hold things. All of these are photogenic activities. As the hearing develops, noises will cause reactions, which not only offer photo opportunities but give you more chance to predict and control certain reactions. Remember to get down to floor or baby level for all these pictures, as well as for the early crawling and walking ones.

TIPS FOR THE CHRISTENING

- Arrange with the priest to pose pictures at the font either before or after the ceremony.
- Use a lens wide enough to include some of the church in the pictures.
- Use a medium speed film to preserve good colour and detail.
- Use fill-in or slow flash modes in poor light – diffused flash if there is almost no natural light in the church.

In no time at all you will be photographing the first of many birthday parties and trying to catch the reflected flicker in the eyes from the candle on the cake. Remember to switch off the flash for these photographs.

For all photos of babies and children use soft light and avoid hard sunlight. Diffuse or bounce flash.

AFTER THE FIRST YEAR

If you want pictures of nice, tidy, clean children beyond a year old to put in your album or to send to your own parents, you will need to prepare an area indoors where you can take a series of

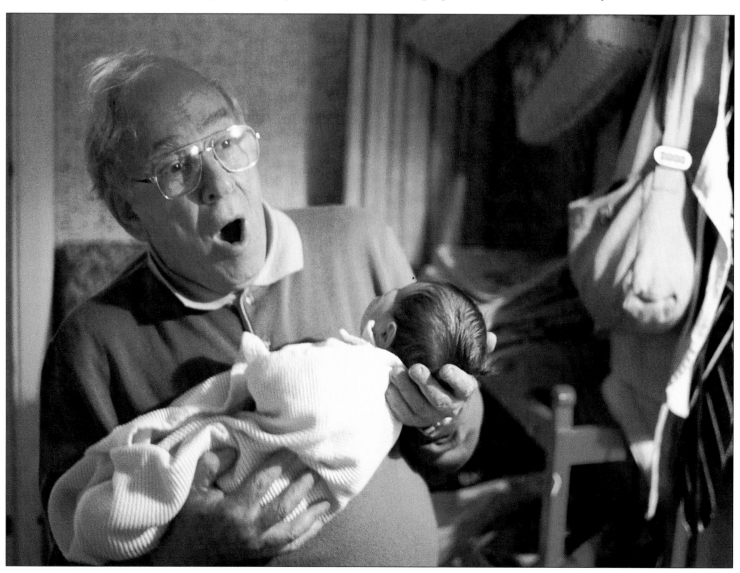

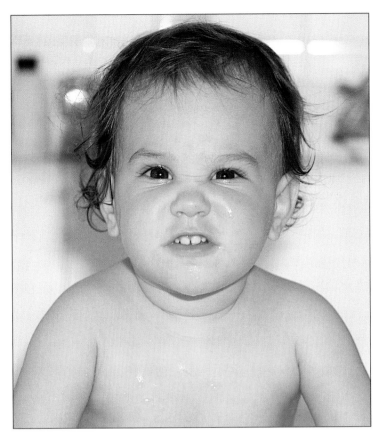

special portraits. Otherwise, tag along with them and take the shots which reflect their fascination in the discoveries of walking, falling over, climbing, the wetness of water, the slitheryness of mud, plus the myriad physical sensations they get from such things as eating too much ice cream or plashing through puddles, experiencing the discovery of uncontrolled laughter.

Pictures will occur at any time so try to be ready. During these years some people keep a loaded camera handy all the time. The best camera in this instance is an automatic – exposure, focusing and flash – with a zoom. Its size and weight makes a Compact ideal.

For indoor portraits of children prepare a place with good daylight. Avoid direct sunlight by diffusing it with gauze or net curtains and choose a background that is plain or uncluttered. Prepare to work fast as young children have short concentration spans. Although you may want a waist-length or head-and-shoulders picture, avoid getting too close to the child, and use a narrow angle lens to fill the viewfinder. Let children work off their inhibitions by snapping any expression they come up with. Thereafter it will be easier to get their co-operation for the sort of poses you may want. If the session is not really working, give up. Children seldom disguise their off-days and there is no point in trying to get smiles unless they come naturally. Your aim is to snap natural expressions.

Above:
Bathtime is wonderful for capturing a great range of expressions!

Left:
Small babies need to be supported for photos. In this case it results in a portrait of both baby and grandfather.

Right:
Be prepared to spend time and energy amusing a baby to provoke interesting reactions for your camera.

Whether you want posed or informal shots, children's quick eye and facial movements will mean that you will need to set a fast shutter speed (1/250 of a second) and take several pictures to ensure success. Informal photos will either present themselves as part of a developing domestic situation or occur as the youngsters have become engrossed in some activity and have forgotten your presence. Anticipate and shoot. After that look to see if you could improve the background or angle of view; if you can and the situation has remained the same, shoot some more film. These sort of shots call for observation and patience.

Good informal pictures can be of all sorts – close-ups, group shots and wide angles. Take pictures of children of near or school age in the environment they have done most to create, such as their own room. However you feel about it at the time, it will say much about that stage of their development!

PORTRAITS

At various times in the life of a family there is a need for the sort of photograph that marks a punctuation point: at the time a child is starting school or college and you need something which summarises their character at the point it is likely to undergo a change; or the occasion in your parents life which signals they are entering a new phase such as retirement or a golden wedding anniversary. These need to be commemorated and marked with a few photographic portraits.

It seems surprising that more families do not take their own portraits. Hopefully, your family knows, loves and understands you best, so why leave this recording to strangers? Any camera with a lens which is capable of sharp pictures is suitable for the job. The most important qualities for creating a family portrait are patience, an eye for light, a knowledge of the sitter to anticipate the next mood or move and a mutual respect between the sitter and photographer.

That mutual respect will mean that whether the subject is grandfather, stepson, niece or partner, you will have a feeling about their character. So, when you are looking through the viewfinder you will automatically wait to push the shutter button until you see something of that character. You will also have the knowledge to provoke reactions and cajole – or bully – your sitter into the right mood.

Remember though, that people having their picture taken very often reflect back the mood they get from you.

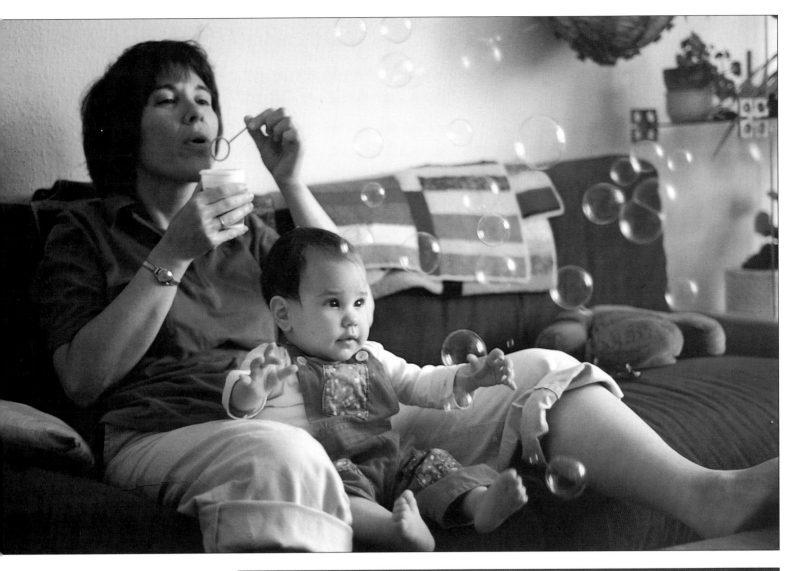

Above:

As soon as children are able to concentrate on external stimuli engage them in activities to take pictures.

Left:

Not all baby pictures need be smiling.

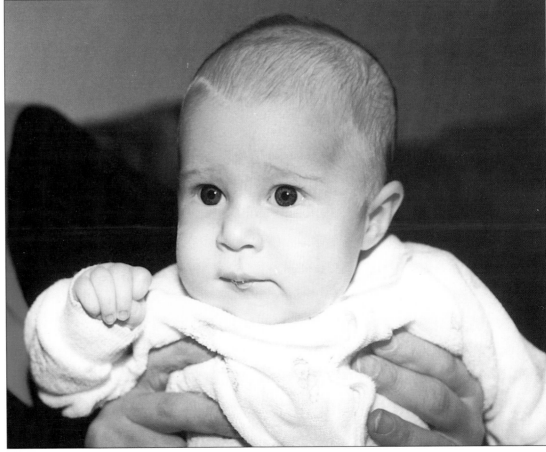

Right:

Small babies not yet able to sit need to be supported by cushions or held for photographs.

DECISIONS TO MAKE

• Perhaps the most important decision, or agreement, to be made beforehand is that both of you will give the occasion the time it deserves. But there are others considerations as well: do you want to make the portraits formal or informal; where is the best location to provide either a neutral background or to provide more information about the sitter – indoors or out, and what type of light do you want to use?

• Provided the location gives you the technical facilities you need, the only other consideration is will the subject be relaxed? It often helps to pick a place which adds to what you know of the subject. But, although a craftsman should be relaxed in his/her workplace it is unlikely that a teenager, for example, would feel comfortable in a lecture room with fellow students looking through the windows. Equally, a country walk may be right for your partner but an elderly relative could be distressed if it reveals a degree of infirmity.

• Always use daylight. With people who are happy outdoors in strong light, try putting them with their backs to the sun and using fill-in flash. Generally, try to avoid shooting in strong sunlight – cloudy days are best for portraying faces. Otherwise choose good light in the shade or from a window. The light will be soft enough to flatter but will also come from a noticeable direction.

Directional light gives shape to a face but if the light is too strong there may not be any detail in the shadow. Some women and older people look better with a more frontal soft light which will give less defined shadows. Try soft focus with a special lens attachment or cover the lens with cling film.

• Whether your subjects are standing or sitting, ask them to turn their bodies towards the light. You then have a choice to move around them until you have a good angle or the light is in a position you like. Usually this means that your subject can either turn his or her face to the light or the camera and be well lit in either case.

If you are taking a portrait of someone wearing spectacles, beware of reflections, especially if you are using flash. Instead of positioning your sitter facing the camera, let him or her turn their head a little to one side, but not so far that he or she cannot look into camera if that is what you want.

• You must also decide on the angle of your lens. If you go close with a wide angle it will distort, making noses look bulbous, for example. Zoomed-in narrow angles (85-120mm) are best; you can shoot close-ups from a respectful distance and the focus is shallow enough to soften busy backgrounds.

• Think about the difference that camera height will make to your picture. Round faces usually are best shot from above (looking upward strengthens the jaw line); however the reverse is not necessarily true. If your camera is below eye-level it can suggest that your subject is powerful and tall but if he or she looks down into the lens the result may not flatter, depending on their age and the stiffness of the neck.

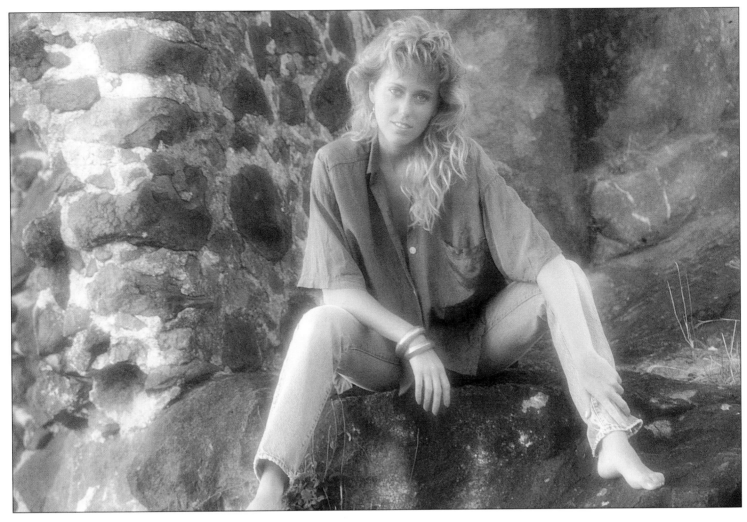

Top left:
Although not really relaxed this subject's facial tension adds the element of character.

Above:
Soft light smooths faces. The reflected sunlight adds charm and warmth to this girl sitting in shade. If the sun is strong, use any white surface or even newspaper to reflect the light.

Left:
Relaxed faces make good portraits. Sun and sea produced the right moment.

Left:
Backgrounds are very important. They should not distract but be appropriate. The clear, bright colours of an inflatable 'castle' are very suitable for this portrait of a young girl.

GROUPS

The whole family, the sports team or social club – group shots are actually just another sort of portrait. But because many people are involved you do need to do some preparation. Groups of any age have a limited attention and patience span. The whole situation can soon fall apart if you are not sure what you want and clear in your instructions to the group.

• Choose your location beforehand.
• Have an object or feature around which people can group – a gate, a footpath stile, a bench, a big armchair – or something which frames them such as a veranda, goalposts or a doorway.
• Wherever the location, ensure that the light falls evenly on all the faces. Avoid uneven sunlight, dappled shade and flashlight with groups arranged in depth (the nearer ones will be bleached out, the furthest in dark shadow). Daylight with even clouds and open shade are best. If you do use flash, keep everyone approximately equidistant from the camera.
• Have a clear idea of how you wish to group people. With young people it can be better to let them choose their own grouping. Whatever you decide, do it quickly. If people get bored or uncomfortable, the results will be strained.
• Arrange people closely together; gaps between people will be exaggerated by the camera.
• Put people with bright clothes or carrying bright objects to the centre; it will concentrate the viewer's eye.
• Help people do something with their hands – perhaps hold an object or a chair arm or a child.
• The larger the group, the more entertaining you may need to be to get and keep everyone's attention when you need it. When you are ready shout, sing or blow a whistle – anything to get and hold the ir attention.
• Try to shoot quickly but make sure you take lots of pictures. The more people in the group the more chance that someone will have blinked or moved in a shot.

Above:
This unposed two-shot captures all the boys' youthful energy.

Below:
Childhood facial expressions are fleeting; you need to keep a camera handy on all likely occasions.

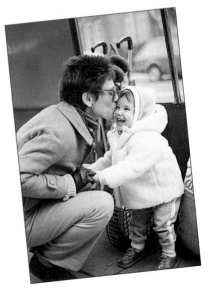

Above:
The sense of pleasure between mother and daughter captured in this photo overcome any awareness of the slightly fussy background.

PARTIES AND CELEBRATIONS

Like weddings, parties are a combination of the formal and informal. However chaotic the children's birthday party there will always be a special moment – perhaps the cake or the gift. However sedate the grandparents anniversary, after any welcoming speech people will soon relax. Your camera will be expected to do justice to both.

• If there is to be a candle-lit happening (such as a cake or christmas pudding) use fast film to avoid the need for flash (ISO 400 and above).
• Make good use of your zoom (if you have one). Zoomed out wide it will be ideal for covering the formal moments which are likely to be small groups; zoomed in it will catch close-ups, such as reaction to events and later more candid moments. For a camera with a single lens – about 50-80mm would be a good compromise choice.
• Use fast shutter speeds – 1/125 of a second or faster.
• If you have to use flash, diffuse or bounce it.
• Load a fresh set of batteries and have a spare set standing-by.
• If you have a tripod, put yourself in the group by using the self-timer.
• Make sure you get the candid photos; anticipate the moment and shoot without hesitation.
• Preset the focus to the distance where most people will be; this way when when you are ready to shoot either you or the AF (auto-focus) mechanism will have only a small adjustment to make. For non-AF cameras it may be faster to lean in or back from the subject than make small adjustments to the camera.

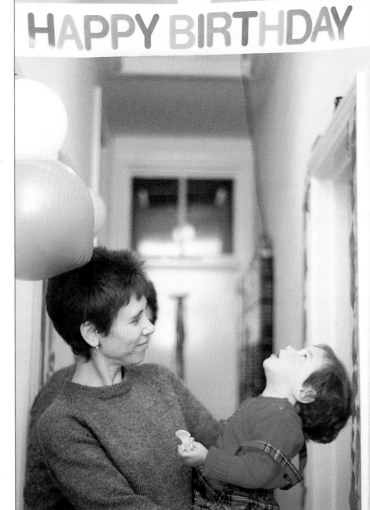

Above:
Children's parties often result in good pictures because the children forget any camera-shyness.

Below:
Luckily the use of flash has captured this child's happy expression and also some of the background merry-go-round.

Above:
The low camera angle and the little girl's sense of sliding are given charm by the slightly comic hat.

EVENTS

This section covers the events we all attend at various times, with friends, relatives and of course, the children. And afterwards everyone wants to see the photos!

PROCESSIONS, CARNIVALS AND FESTIVALS

As anyone who has ever waited by a crush barrier for a VIP or a procession to pass knows, your viewpoint decides if it was all worthwhile. Any place at ground level needs an uninterrupted view to make the best of those precious few, over-in-a-second moments when everything happens.

• For the best pictures find a place above ground level. The ideal view should be from a first floor room in a corner building that will be passed by the procession. Being about seven metres off the ground, it should be above any stands and crowds, but not so high so that only tops of heads can be seen. You should have a view of the procession approaching, thereby getting good group shots. There should also be opportunities to shoot people on or inside vehicles as the procession passes. If you are really lucky the procession will turn the corner of this building giving you a second chance to get good shots.
• If you are shooting from ground level try to get wide angle shots holding the camera very low; this generally eliminates confusing backgrounds. If you want someone in the shot to give perspective put them to the side of your frame to avoid blocking important details.
• Telephoto or zoomed-in shots will give good pictures of individuals or small groups on or in vehicles. There will be less problem with backgrounds as the shallow focus of the lens will soften them.
• Wherever you find yourself, fill the frame with the subject.
• Use a shutter speed of 1/125 of a second or higher to prevent movement blur or camera shake from a telephoto lens.
• If the camera does not have AF, frame an attractive picture, pre-focusing on a spot which any cars, carriages or floats will pass and then press the shutter as the vehicles arrive at your focus point.
• Use film of ISO 400 or faster; even in bright weather the extra depth of focus and the high shutter speeds will be helpful.
• Although a procession is usually an important part of a carnival, there is generally fairly free movement around a series of fixed points. If you have only a wide angle lens, whatever the activity, get as close as you can. If you have a zoom or telephoto, being close will let you take big close-ups of the performers. And look for the reactions from the spectators, too.
• Wander around and look for opportunities to take candid shots of friends and family. Look out for colourful individuals in the crowd as well.

Remember that if you use flash there should be nothing or no-one closer to the camera than your subject. If there is, either your subject will be dark and the foreground correctly exposed or the foreground will be over-lit (bleached out). Both are situations which will spoil your picture.

Below:
On some occasions party light levels can be too low to use anything but flash.

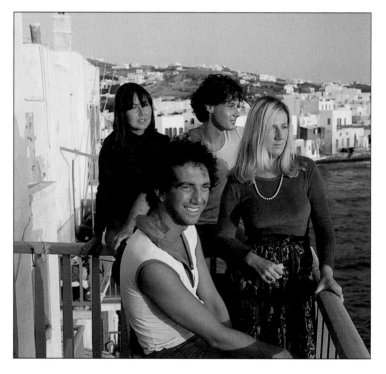

Above:
Another informal group. As they all look towards the evening sun over the sea there is light on all the faces.

Right:
Find something to give unity to group photos – in this case the bicycles.

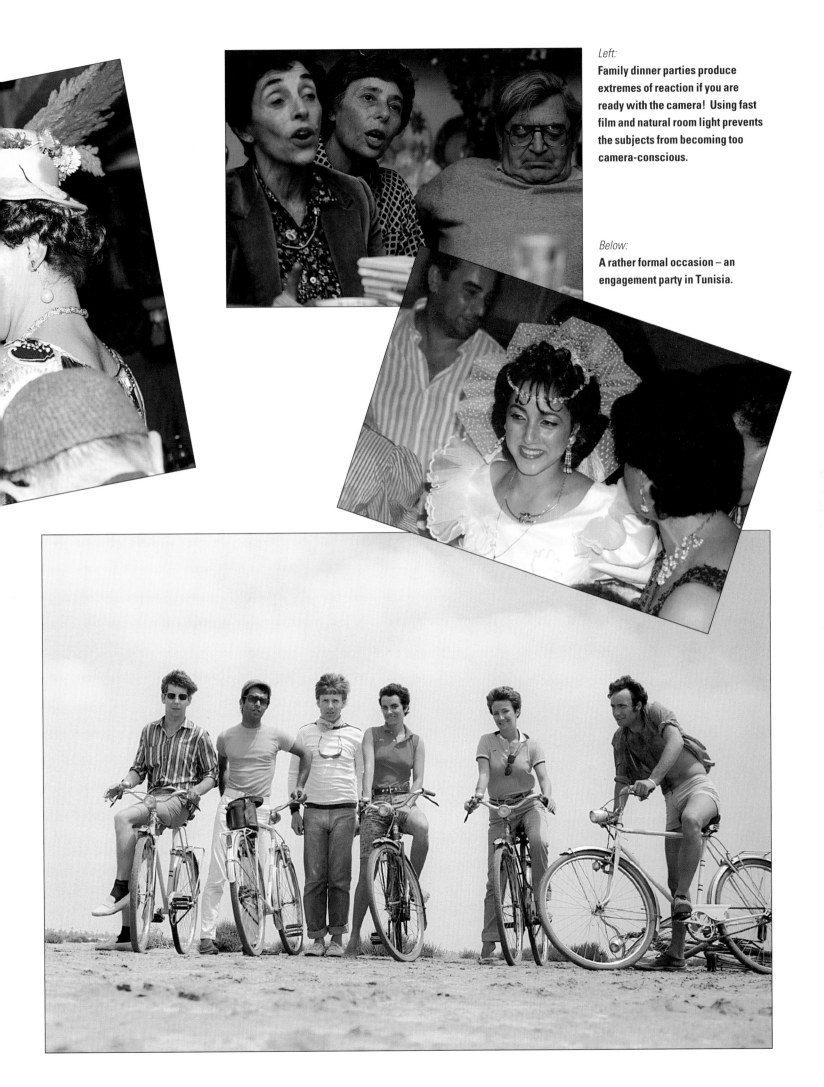

SCHOOL EVENTS – SPORTS, PLAYS, CONCERTS AND CEREMONIES

School and college play an important part in everyone's life and it would be a pity if a family album had few pictures to reflect this time. The range of events which happen during this period will test any family photographer's skill; most of the techniques to deal with them have been covered with in other parts of this book but here are a few additional pointers.

SPORTS

• For track events and swimming, try to get a position in front of the finishing line; it will be easier to keep competitors in focus and sharp than being at the side. If you cannot be at the finish, take close shots of competitors from a bend; you will have several chances as they come towards you up right to the moment they pass in profile.

• For team events, high positions show patterns of play; low positions (camera below normal eye level) capture the effort and anxiety shown in bodies and faces. Figures will also be clear of distracting backgrounds as they appear against the sky.

• For cricket matches, use a telephoto lens otherwise you will be limited to shooting the scoreboard and the players as they walk to and from the wicket.

• For swimming, use flash. Indoors in particular, you are unlikely to be able to use a fast enough shutter speed to freeze the action.

• Shoot spectator reaction; it helps to capture the atmosphere.

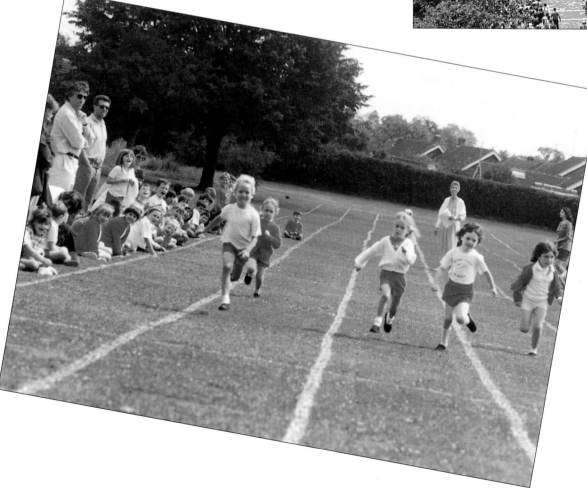

Above:
Distant photos of big processions are often successful because they can reveal the sheer scale of both the procession and the crowd reaction.

Left:
Track sports – at any level of expertise – are best seen from the finishing line. If you are in front of the participants you will not need such a fast shutter speed. Unless you have AF, preset the focus and as the athletes are about to reach the spot, push the shutter release.

Right:
Indoor concert or outdoor marching band – ensure that musical instruments can be seen as clearly as the players.

Above

A zoom or telephoto lens is needed if an event or ceremony takes place over a large area, like this military passing-out parade, or your photo view will be very distant...

Right:

Either insufficient light or distance from the platform make indoor ceremonies (like graduautions) difficult to photograph. Capture the feeling of the event by taking your pictures outside the hall as soon as you can.

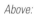

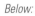

Above:

....better to take closer shots of the finery before or after the event.

Below:

Games such as cricket usually need a telephoto to get close to the players and show the finer points of play, but the reverse is true when the setting is attractive.

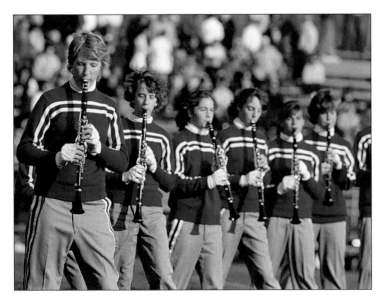

PERFORMANCES

For stage plays get as close as you can to the action; a lot of it can only be shown in waist shots and close-up. Nothing is worse than a vast stage space with tiny, insufficiently lit, infant figures in the background. Seek permission to shoot at the dress rehearsal and use a telephoto lens or zoom close. If your camera lens cannot get sufficiently close then you must ask to go onto the stage, pose shots or ask the players to re-enact short sections.

Here are some other pointers for taking photographs at such occasions.

• Use high and low camera positions to underline the dramatic action. Take moments of physical action or 'significant looks'.

• At dance performances overhead shots reveal dance patterns; eye-level shots of the whole figure show the all-important body line.

• Singers look best, whether solo or groups, shot slightly from above, to minimize the effect of looking down to the tonsils in wide open mouths! Profiles are just as effective as front shots.

• Musicians should be photographed playing, although it is not always necessary to show the whole instrument. Take pianists from a position that shows their hands on the keyboard, woodwind and brass instruments should not obscure the player's mouth and string players' hands should be seen.

• Use the fastest film possible (ISO 1000 or higher), with a shutter speed of 1/125 of a second. Flash will spoil the atmosphere and, even if permitted during a performance, will annoy spectators. If the existing stage lighting is insufficient (or awful!) arrange a special photocall and use diffused flash.

Awards ceremonies present difficulties because rarely can you get close enough to the platform to photograph the significant moment. Use the fastest film possible (ISO 1000 or higher), with a shutter speed of 1/125 of a second. Switch off (or cover) the flash; it is unlikely it will be powerful enough further than five metres from the camera. Use the available light and use a telephoto lens (about 200mm) or zoom in close. Be careful of camera shake though; support the camera.

In addition (and in case the ceremony shots are unsuccessful) take a full or waist-length shot of the happy recipient holding his or her award(s) immediately after the ceremony. Shoot it in the ceremony location if at all possible, using slow or diffused flash if the available light would not allow a shutter speed of 1/125 of a second Place your subject where it is possible to see the whole of the interior or the whole of the platform behind him or her (the front of a balcony or circle will often give a better view than downstairs). If the interior of the location cannot be used, try the exterior, using as much of the building as possible in the background.

Whenever you use artificial (tungsten) light with negative (print) film, tell your processor and ask to have the affected shots colour corrected. If you are using slide film make sure you buy the correct type – daylight for daylight and flash shots; tungsten for most other types of artificial light.
Below:

For plays and concerts use fast film and the stage lighting. Remember to tell your processor that you have shots taken by artificial light on the film roll.

HOLIDAYS

Although most of us take pictures to remind ourselves of the places we have visited and the good times we had while we were there, we rarely take advantage of all the picture opportunities offered on our holidays – or even day trips. Hopefully this section will give you some new ideas and increase your chances of getting a more individual style to your shots.

Most pictures look better with people in them; it gives a sense of scale and movement. But it is not necessary to have friends and family prominently in all of them. One such picture per album page will remind you that you were there. Increase the interest of your photos by their variety and composition.

Unless you are visiting a place which will sell film brands familiar to you, take film with you in a range of speeds. Most of the situations you will encounter are likely to be sunny – fine for mid range speeds of ISO 100-200, but what about the occasional dull day, the interiors of castles or museums which may prohibit the use of flash and those evening meals and parties? These are all times when a very fast film could capture the fun without the flat, strong light of a flash destroying the atmosphere. Take films with speeds of ISO 800-1600. And if you have a hobby which involves photographing objects with fine detail you will want the slow, colour rich films at ISO 25-64.

Buy short lengths, 24 exposures or less. It may seem cheaper to buy a film with 36 exposures but often you will find yourself stuck with finishing up a film with an unsuitable speed – and nothing seems worse than having to use up 10 pictures on an empty, windswept beach just because you want to load fast film for an evening of festivities!

Take extra batteries with you. In the cold of winter they will discharge faster, while in summer you may find that the extra

Avoid putting someone in the mid distance, in the centre of the picture. If you want them as part of the scene:

- ■ **Make them a part of the composition by placing them to one side or around the edge of frame.**
- ■ **Bring them much closer to the camera and have them in profile, apparently looking at the scene beyond.**
- ■ **Let them take part, if a specific activity is the reason for taking the picture.**
- ■ **Take a special close shot if they are reacting strongly to events. Whether registereing pleasure or distaste it could make a great shot to recapture the atmosphere.**

Remember, if the scene is sufficiently interesting it will justify a photo of its own; it could be that your family and friends are blocking the view!

Above right:
If you want friends or loved ones in your holiday pictures avoid standing them in mid distance and the middle of the picture, try to make them a part of the composition. (Hvar, Dalmatia).

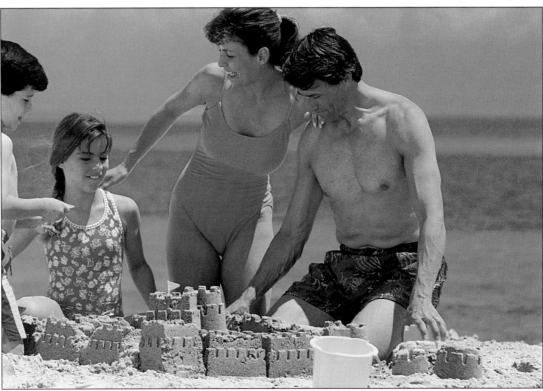

Right:
Especially with family groups on the beach, try to get everyone involved in some activity. It will bring back more memories than faces with fixed grins staring at the camera.

use (especially of the flash) runs them down unexpectedly. Keep them well packed; the ends of loose batteries may touch accidentally, discharging them.

Lastly, remember to take the camera cleaning kit with you..

BEACHES

For many people a beach is what the holiday is all about, so what better place to capture the essence of your trip? Unfortunately the bright light can be deceiving and dust and water tend to make for a somewhat hostile element, but if you smile, you can overcome many of the problems. Both adults and children can be very unselfconscious in a range of activities which will make photo album treasures later.

The beach is *THE* environment for children. Zoom in to fill the viewfinder with groups or single children as they are absorbed in their games. Use fast shutter speeds to capture them

splashing and running in the water and zoom out to wide angles as they explore pools and gaps between the rocks. Be on the lookout all the time for close-ups of faces – laughing, reacting, putting on or taking off goggles. You know your children and you should be able to anticipate what will get a reaction; just train your trigger finger to anticipate what suddenly appears in the viewfinder.

And remember that adults play, too. Get the whole party playing beach cricket or running races. The full gamut of photo opportunities will be presented to you to get action groups, happy close-ups and even spectator reaction.

Afterwards, or in the heat of the afternoon, wait for people to doze, read or cover each other with suntan lotion – all good chances to capture the ways in which we reveal our personalities as we relax.

Do not limit yourself to dry land only; join others in the boat towing the friend who waterskis. With fast shutter speeds to

overcome the boat's vibration, such pictures will be very popular. Or use a boat or pedallo to shoot the family on the beach, or a swimmer alongside – just the shot for using the flash.

Take a shot of the whole beach, just to show how good it was. Use an unusual angle; shoot down on it from amongst the pine trees on the cliff; frame it with the doorway of the awning or your favourite cafe. Take it in the evening sunset, using the self-timer so that you can have a silhouette shot of you and your partner. If it was romantic at the time, be romantic with your camera!

Beware – avoid shooting at midday, especially in hot climates. Being so high overhead, the sun creates lighting contrasts that drain the colours. It is also a very unflattering light for faces and makes people squint.

Take care of your camera. Cover it when not in use to prevent sand clogging the works or corroding sea water damage. Avoid it getting too hot or you will damage the film inside, or at least affect the colours. (Also take precautions to avoid it being stolen).

Use a waterproof camera to keep out sand and corroding salt sea. You can buy either waterproof or sports versions of some Compacts, or you may prefer to buy a waterproof disposable.

Watch the exposure. Bright sun on sand and sparkling sea confuses many metering systems and the result can be dark, under-exposed photos. Use one slower shutter speed or a wider aperture.

[If you cannot switch off the automatic systems of your camera, or do not have the ability to change these settings manually, refer to Cheating the Systems].

Right:
Pictures of your favourite beach rarely look good taken from the level. Looking down often reveals the shallows and colours of the sea.

Left:
...or shows the bright colours of the beach umbrellas.

Below:
Safely splashing in the waves is often enough activity to generate good pictures.

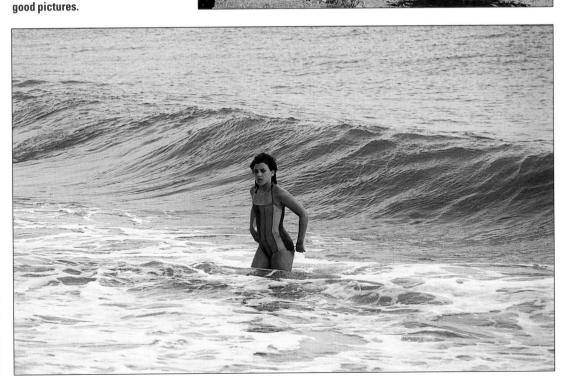

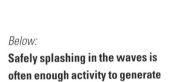

49

ZOOS AND NATURE RESERVES

More and more people are spending leisure time looking at the wildlife around them and the opportunities now extend far beyond the traditional zoo. City farms, nature trails, bird and wildlife sanctuaries, safari parks – these all offer chances for great photos, so remember to take the camera with you!

Because the purpose of the trip is observation, patience and stalking your prey are a part of the experience – exactly the qual-

Below:

Try to use shallow focus to separate animals from their backgrounds.

ities needed for good photos. Sanctuaries usually provide hides, but in places where you are free to move around, try to keep a low profile and stay downwind of any animal so that it is less aware of you. Assess the animal's habits to help predict what its movements might be.

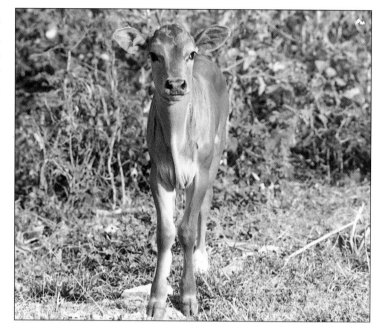

Feeding times make good pictures; watering places will give group shots as the animals gather. Tempt animals in public parks with meat or breadcrumbs as bait. After feeding and in hot weather many creatures will snooze giving you the chance for a different type of shot.

Unless you have a reason for showing habitat frame the animals as big as possible in the viewfinder. Cutting out the surroundings often makes them easier to see and certainly avoids distractions. Avoid getting an animal half in, half out of shade. That also can make it very difficult to see. If you have to shoot through bars get as close to them as is safe, so that they will be unnoticeably dark or out of focus. Use flash to freeze the movements of birds and small animals; you may need a tripod in a hide or in situations where a static position is advisable.

Remember to check on any restrictions or regulations in wildlife reserves. Many are for the benefit of the animals, but others are for your safety. Do not open car windows to take shots in safari parks.

Below:

Or, set the animal within its habitat.

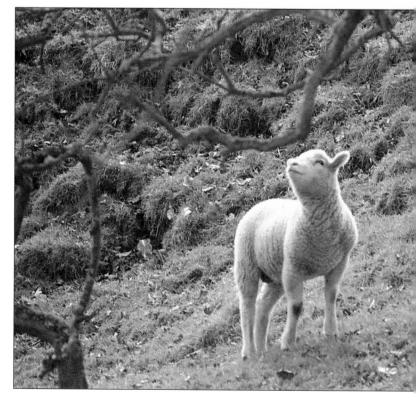

USE FAST FILM

• Use narrow angle lenses or the closest zoom setting to bring animals in the distance closer. Use a close-up lens or macro facility for small creatures.
• Use the flash for some shots but try not to be square-on to glass viewing panels or you will reflect the flash back into your picture. Shoot through them at an angle.
• With AF cameras, either switch to manual or use the infinity setting, if you have it, to prevent the system focusing on the glass viewing panel and not the subject.
• Use fast shutter speeds – animals generally make small, very swift movements.

Left:

Feeding times and after offer a time when animals are less lively and easier to photograph!

Below:

Where it is safe to do so, go close to fencing or the bars of animals in cages. Either shoot through a gap or ensure that bars and netting are out of focus.

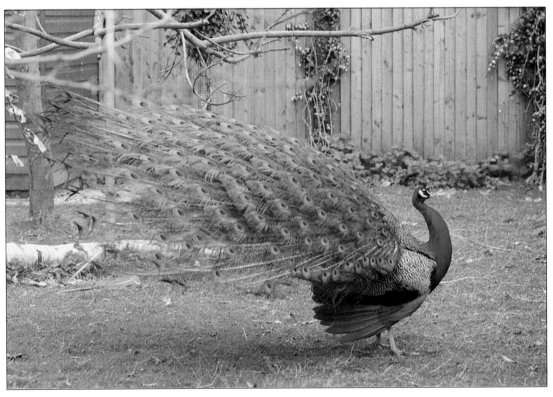

51

SNOW

Whether you are enjoying a winter holiday or just wintery conditions, snow and snapshots go well together. Friends and family wrapped up in warm and often colourful clothes, children at the ski lift, sliding along on sledges or simply throwing snow balls; these all present superb photographic opportuinites.

The main thing to remember is that with so much whiteness around, your camera's auto-exposure system may get confused and under expose your pictures. For close-up shots of faces this is not a problem, but if the sun is strong and clear – especially if it is high overhead or falling on the side of the face – use fill-in flash. If there is a blizzard raging and you want to catch the sensation of the flying flakes, use fill-in or even slow flash.

For snowball battles use fast shutter speeds; for tobogganing and skiing, (see section on Action). If you want more distant views of landscape or skiers, try to break up large, white areas with foreground objects. Fences, rocks and people will all add interest and give depth to a composition.

Unless you particularly want atmospheric shots, wait for some sunshine. Grey skies turn snow grey or give it a blue cast. The best sunshine is when the shadows are long, early morning or mid-afternoon. They add extra shapes and so extra interest to a shot. Avoid times when the sun is at its highest; contrasts will be extreme and the colours will seem drained in the result.

For woodland and countryside scenes which are impressive and slightly unusual, try shooting against the sun, the shadows falling towards the camera. Avoid the sun shining into the lens (causing flare – dark and white streaks) by hiding it behind trees, rocks or a wall. Use the backlight or exposure compensation button to avoid under-exposure.

For correct exposure of snow pictures increase your exposure by at least one stop – open the aperture one or two stops (eg from f11 to f8 or f 5.6) or set a shutter speed slower (drop from 1/250 to 1/125 or 1/60).

[If you cannot switch off the automatic systems of your camera, or do not have the ability to change these settings manually, refer to section Cheating the Systems]

Above:
Use colourful snow clothes to help your subjects show up against large areas of white snow.

Left;
Snow scenes can be tricky if there are large areas of white. Most automatic metering systems try to expose the white as a light grey, causing underexposure. Even though this shot should not be a problem it could be wise to take an exposure measurement from your own hand as a check.

DULL DAYS

Dull holiday weather has its compensations – it offers good opportunities for snaps.

Take pictures of people in such conditions, particularly close shots; the light is softer and more flattering. Avoid too much overhead light (and dark under eye shadows) by standing people under a shelter, canopy or even an umbrella.

Take pictures of water. Fast flowing rivers and waterfalls often look better without the distracting highlights given by sunshine and the slow shutter speeds needed by the less intense light blur the water to give it a softer, more liquid look.

In spring and autumn dull days can make woodlands look more colourful. Choose a viewpoint which shows very little sky. This reduces contrasts in the light and helps show the colours to better effect.

For the same reasons shots of gardens, particularly close-ups of flowers can be very successful. (Real enthusiasts may even want to try using a polarizing filter to get that little extra colour.)

In fact dull days provide the best opportunity for shooting all those close details that strong sun can spoil – baskets of local produce in a country market to remind you of the food you ate, carvings on buildings seen on a day trip, the children's sand-castles as the tide makes wet patterns on the beach.

Even landscapes are possible. A distant view can be brought to life by a colourful object in the foreground. Roofs, cobbles and other surfaces made shiny by rain give views an extra lift. And in a view of rolling hills and mountains use dark, stormy skies or distant shafts of sunlight to give a sense of drama.

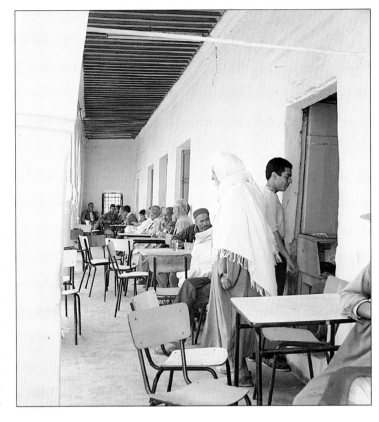

Above:
Dull days often mean the removal of heavy shading from areas otherwise too dark to photograph in -like this Tunisian cafe.

Below:
Unexpected summer sea mist provided the opportunity for this dramatic lighthouse picture.

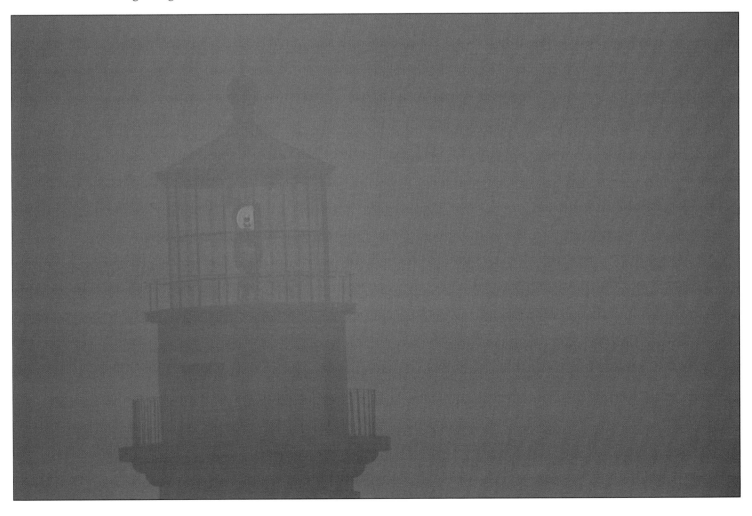

SIGHTSEEING

The whole purpose of travel is to see new places and people; capturing them on film without trouble takes no more than a moment.

Do be courteous. You have no right to snap everyone and everything. Some people may have religious, cultural, or political reasons why they do not wish to be photographed. Or they may simply be shy. Some countries have categories of buildings which have restrictions regarding photography – airports for one, factories for another. If you are uncertain about local conditions ask local tourist officials or your hotel representative.

The journey itself may offer good pictures. and your companions may like the idea of a group shot. The vehicle may be unusual or have unique features! And there are always pictures along the way, some of which have to be taken on the move.

To get successful shots from moving vehicles is not easy. Set a high shutter speed and use a wide or normal angle lens to overcome vibrations. If you have an AF camera, glass windows may confuse it; use manual or the infinity setting. Avoid reflections by putting the lens close to the glass and shooting through at an angle – and avoid vibration by not leaning against it. You cannot expect pin sharp picturesin these conditions; shooting through glass refracts light to some degree, softening the focus.

High views from aeroplanes often have a colour cast due to haze and the ultra violet in the light; fitting a UV filter can help. In trains and cars, if you are able to open the window, beware of oncoming vehicles or objects which may block out the view or endanger you. Shots from inside a car can often be effective when you frame them with the windows or the windscreen.

Do not be so busy looking that you miss the obvious. Shots of your immediate holiday surroundings may bring back more memories than those of a dozen daytrips you take during your stay. Whether you are staying in a town or village, it is always worth a shot of the main street at its most characterful time of day. Think what it is that gives it its atmosphere – the women

TIPS TO TRY

- If possible, visit early or late to avoid crowds, cars and souvenir-sellers spoiling the atmosphere.
- Show shapes and colours to advantage by shooting early or late when the sun is lower in the sky.
- Avoid showing too many people in shots of peaceful locations by moving in close to shoot a particular part of the scene. The chances are that most visitors will leave such a small area in a couple of moments.
- Try using narrow angle (zoomed-in) lenses to photograph whole locations from a great distance. The shallow focus and flattened perspective can help to isolate buildings or exclude unwanted details.
- Use your widest angle lens for interiors to show as much as possible. Avoid including cars, rubbish or other unwanted detail by moving left or right, high or low. Let a clump of grass, a piece of furniture or a pillar block such problems. Or frame them out by shooting from a window or doorway.
- Frame outdoor locations by including trees and bushes to give depth to the picture. It is not unknown for these boughs and branches (called 'dingle' in the trade) to be portable!
- Use flash to photograph such details as carvings on days with strong sun. It can help to reduce contrast and reveal more.
- With unusual shaped landmarks or architecture, show the scale by including figures or other familiar objects, such as trees, horses, even a bus or a car.These should not dominate your picture though; let them be part of the scene.

Other ways of life are part of holiday memories...

Below left:
A Cypriot shepherd.

Below:
A Greek weaver and her family.

54

Above:

A Cypriot wool spinner.

Below:

Reflected light and a normal (50mm) lens emphasize the squash of tourists shopping in the alleys of the village of Lindos on the Greek island of Rhodes.

doing their morning shopping, a loud and battered vehicle doing its deliveries, the first tram of the day – then show that prominently within the street scene.

And what of the people, those characters who help or colour your visit? They may be flattered if you ask them to be in your pictures. Snap them doing their routine tasks or catch them chatting to your partner. Use a narrow angle to fill the viewfinder with the head and shoulders and make sure that the light falls on the face in a pleasing way.

Streets, markets and bazaars all provide souvenir photo opportunities. Use a wide angle to capture the colour and bustle of crowded indoor markets; zoom in close to fill the frame with the details of the goods and the faces of the sellers. Take care out of doors if it is very bright; shoot with most of the subject either in shade or in sunshine. With half-and-half, the metering system sets an exposure too dark for the shadows, but too bright for the sun. Shoot outdoor markets in the early morning; at midday the sun is too high, resulting in harsh shadows and poor colour.

Famous ruins, buildings and landmarks are often the reason for a trip but do we have to photograph them as we find them? Ask yourself what makes the place unique or attractive? What do you see around you that could show this? You may need to walk about, away from the crowd to find it. It may be a distant view, emphasizing outlines or the setting rather than the place itself; look from high and low viewpoints to find it. Equally, small details may summarize your feelings better – a goat cropping grass around a bleak wall or a swarm of fellow tourists sweating with the effort of climbing to stare bewildered at another lush landscape. Such sights mean that your pictures will have something that others missed.

LANDSCAPES

Landscapes are always an attraction whether they are rural or urban. However, do not be deceived into thinking that they are easy subjects because they are static. Parts of a landscape do move (especially in towns) and in a few seconds a changing sky may change the whole atmosphere. Uniform rolling hills or a horizon with repeated skyscrapers may be exciting when you stand in front of it, but reduced to a postcard size print it can be very boring. Part of the problem is that the eye can see a wider view than most cameras and the brain can interpret many small details quickly, piecing together the story they tell. The challenge is how to overcome the camera's limitations.

Here are some of the ways; try to find others of your own.
• Look for strong shapes in a view. These may be lines made by the land or buildings or shadows or clouds. Decide on the point of interest.
• Find interesting patterns and groups of objects – stone walls or fences which snake away to the distance; repeated patterns of newly planted vines.
• Look for textures of rocks, water, wood and sand. Find viewpoints which show how the light can reveal them even better.
• Use natural frames for the sides of the picture – bridges, tree trunks, overhanging foliage, rivers and streams. They reinforce the nature of a landscape and also add depth.

Develop an awareness for the effects of light in landscape photography. Most views look best with the light coming from the side or towards the camera. When the shadows are longest (at the beginning and end of the day), they can reveal past and vanished detail or enhance the present shapes. Capture the drama as sunshine changes to storm or boiling black clouds are pierced by sun shafts.

Think about where the horizon should be: high in the frame it will draw attention to the land, lower down and you will look at the sky.

Wide angle lenses (or a zoom at its widest) increase a sense of distance and give great depth of focus, a sharpness from far to quite near. Narrow angle lenses (telephotos or a zoom at its highest number) decrease a sense of distance and give a shallow focus. Foreground objects must not be close in this instance – the lens will make them too fuzzy to be recognizable and useful.

TIPS TO TRY

■ Include people, animals or common objects to help give a sense of scale. Make them a general part of the scene; if they are too noticeable and dominate the picture, they defeat their purpose.
■ Try using a UV (haze) filter or even a polarizing one to cut down haze if it is obscuring parts of the picture you want. But remember haze and mist can also have positive effects softening shapes and making a mysterious atmosphere.
■ Reinforce dramatic light with improvized filters. Experiment with yellow, brown or green toffee papers.

Above:
A sense of scale is given to this landscape by the figure on the bridge. (Trodos Mountains, Cyprus)

Below:
Taking pictures through 'aeroplane windows is possible under certain conditions. Check the camera's instructions if you have AF and TTL metering and use high shutter speeds to avoid vibration.

Right:

On certain journeys the people around you can be as interesting as the places you travel to. (Landing at Mount Athos)

Below:

Coaches and cars may take you through wonderful sights but be unable to stop. Avoid shooting through glass (if you can) and use fast shutter speeds to overcome camera-shake due to vibration. (Karpathos, Greece)

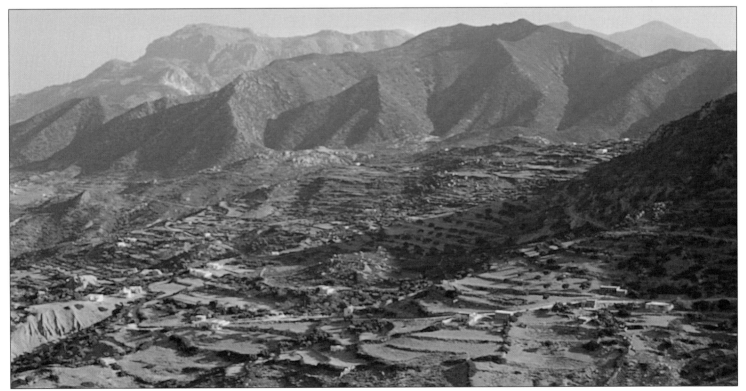

Right:

Landscapes benefit from strong composition elements. Arresting mountain shapes give a geometric strength to this picture, emphasized by the foreground cloud shadow. (The Sierra Nevada, Spain)

Below:

Although the serpentine river shapes are interesting it is the cloud formations that give life to this landscape. (Menemsha Harbour, Martha's Vineyard, Mass., USA)

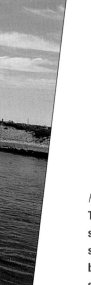

Right:

The overhead viewpoint of a city is still a fairly unusual. Without a skyline it is presented as a series of boxes, but toylike and their lines softened by trees. (Boston, Mass., USA)

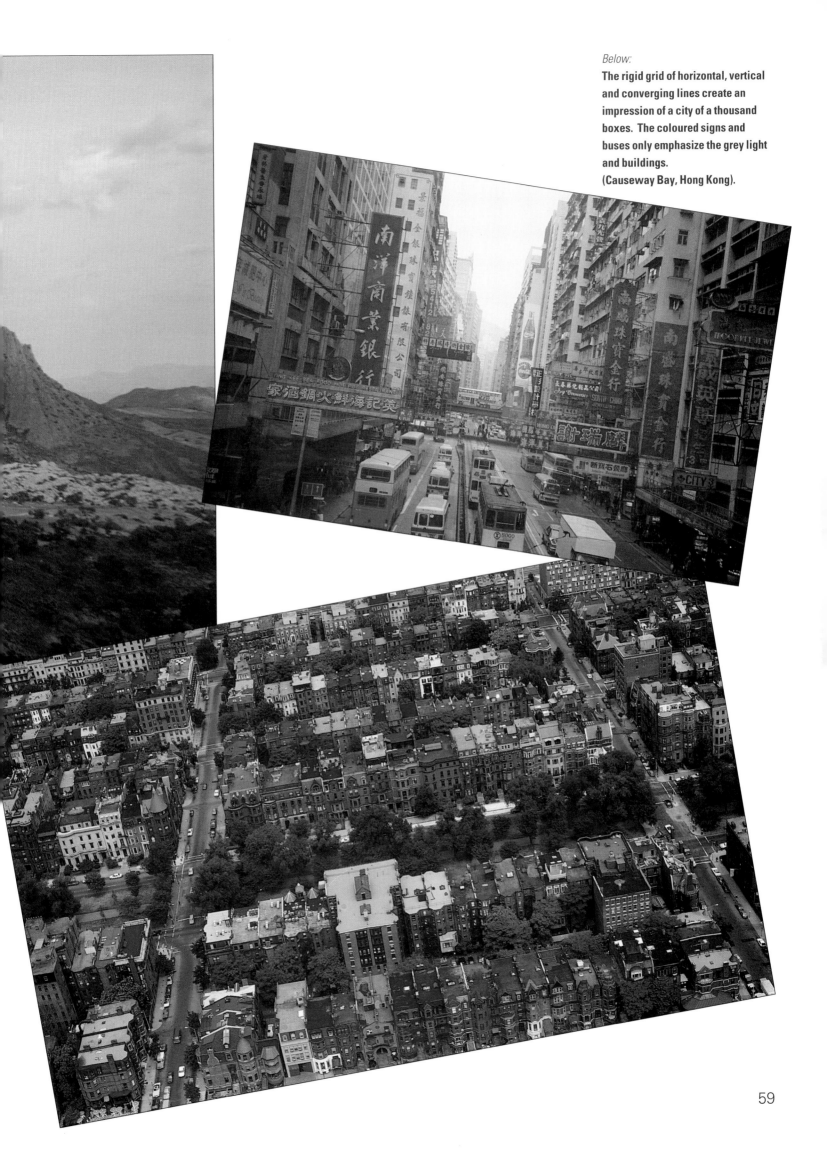

Below:
The rigid grid of horizontal, vertical and converging lines create an impression of a city of a thousand boxes. The coloured signs and buses only emphasize the grey light and buildings.
(Causeway Bay, Hong Kong).

59

NIGHT-TIME

Taking pictures after dark might have been a problem in the past but with today's films and equipment there are few difficulties in achieving satisfactory photographic momentos of places, parties, shows, firework displays and those marvellous holiday meals in tavernas or under starlit skies.

Of course, it is very easy to use flash at night but the harsh, direct light it gives is not suitable for every type of picture. Although there are techniques for overcoming this, the normally available light creates great atmosphere and is often preferable.

The two main points to remember are:

• What night-time light there is will be artificial and therefore give a yellow cast to the picture. Sometimes this can be effective – but not always. It is possible to change the colour cast in the processing – tell the processor when you hand in your print film that the roll contains artificial light shots and you want them colour corrected. (Unfortunately it is not possible for the processor to correct the colour of such pictures taken with slide film.) Buy the appropriate film for the light; transparency film is sold as either daylight type or tungsten (specially for pictures taken in artificial light).

• Artificial light tends to produce pools of light – bright at the centre but very dark at the edges – which makes for big contrasts. This can produce a problem in getting the right exposure. If your camera has centre metering, point it at the bright spots and then at the dimmest (but not the dark areas) and take a note of the difference. If the result is not near the exposure that your camera sets when you look at the whole scene, then use the exposure compensation or backlight button to let in more light. If there are large areas of darkness in the finished picture the processor's automatic printing machines may produce a washed out looking print. Tell the processor when you hand in your film that there are night shots on the roll so that they can be printed accordingly.

When shooting at night using the available light, more than any other style of photography, you need to be aware of just where the light is. If it is not falling on faces there is no point in taking the shot; your eye may see the face, but the camera will not record it.

With fast film (over ISO 400) you should be able to hand-hold your camera for most shots and not need a tripod.

Really fast film is great for photographing at night when shooting faces and some movement, but the penalty you pay is less bright colour and increasing grain. Other sorts of photographs need both the detail and bright colour that slow film gives, despite difficulties imposed by slower shutter speeds.

For parties, barbecues, restaurants and shows (where cameras are permitted) use the fastest film you can get. Particularly if you use the backlight/ exposure compensation button, the shutter speed will be slow. Any speed below 1/125 of a second will need care to prevent the whole image being blurred from camera shake. As with action photography, look for the moment in a movement when the body or head moves least. Then any blurred edges are liable to add to the effect by suggesting speed.

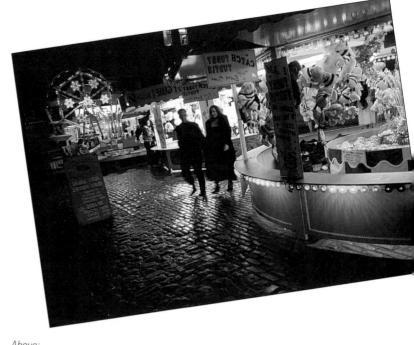

Above:
Night-time lights can be doubly effective when reflected on wet surfaces.

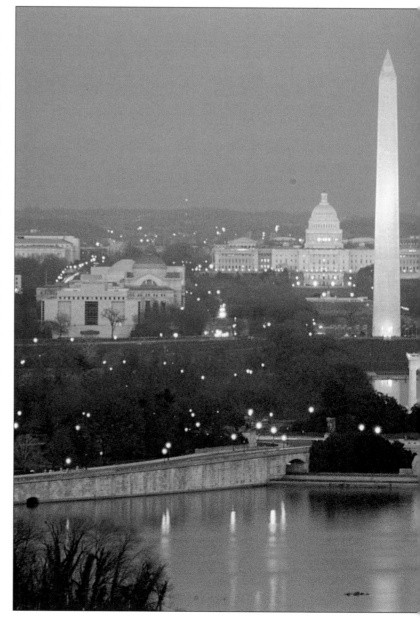

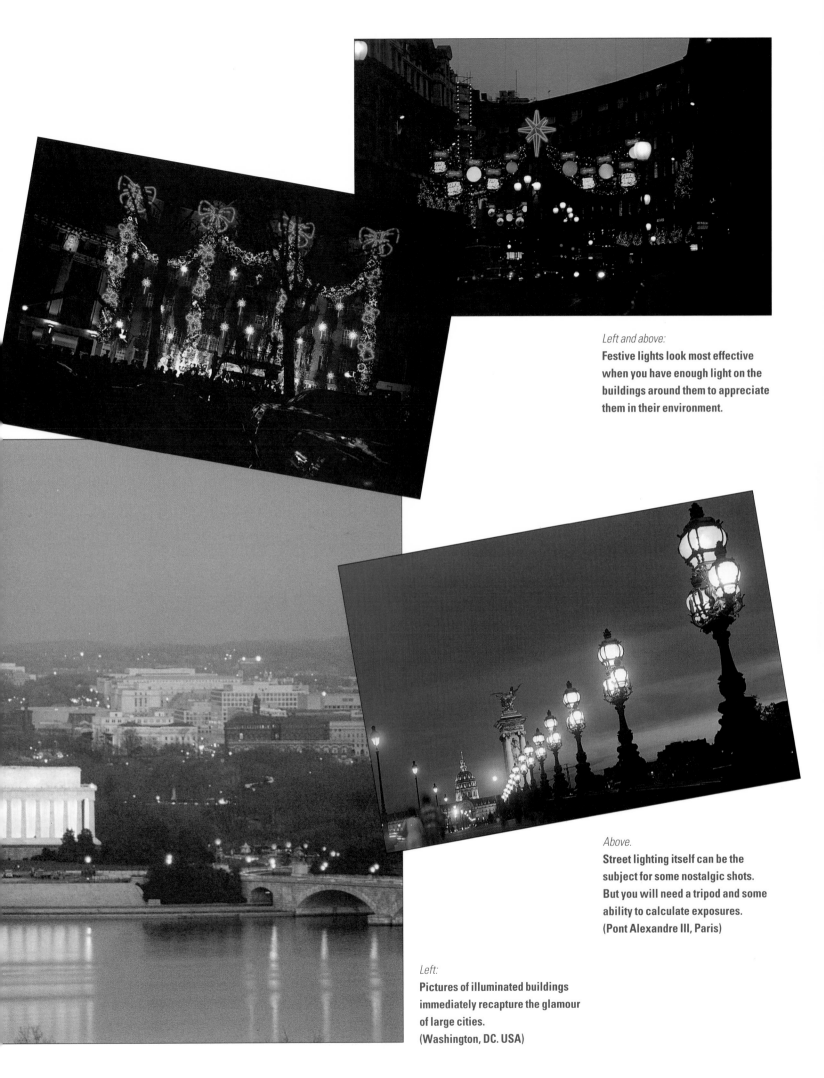

Left and above:
Festive lights look most effective when you have enough light on the buildings around them to appreciate them in their environment.

Above.
Street lighting itself can be the subject for some nostalgic shots. But you will need a tripod and some ability to calculate exposures. (Pont Alexandre III, Paris)

Left:
Pictures of illuminated buildings immediately recapture the glamour of large cities. (Washington, DC. USA)

61

Left:
Both fireworks and the light they give can create interesting pictures but a tripod is essential.

Right:
Firework displays need a multi-exposure technique. Keep the shutter open long enough to record several firework bursts.

If you enjoy visiting fairgrounds,you will want to take some souvenir photos. Their attractions of games and (sometimes) scary rides, all surrounded by coloured lights make them a natural for the camera enthusiast. Start shooting before dark, making as much use of the dusk period as you can – having light in the sky keeps wide angle shots of big dippers and watershutes interesting, the shapes not shown against the dead black of a night sky. Later is the time to take pictures of your companions. Snap them in action playing the games and reacting to one another. When they go onto the rides zoom in or use a telephoto to get a close impression of wtheir reactions. You may need to use flash to freeze fast movements but you have two main choices. Use the slow flash function (if you have it, or use a shutter speed of around 1/60 of a second with your flash, if you can); this will freeze the action of your subject but blur the lights and

background movement. Alternatively use fill-in flash if you have it – if not soften and reduce the intensity of the flashlight by covering it with thin tissue or a handkerchief. This will help light faces but not so strongly that you will lose the effect of the fairground lamps and atmosphere.

A disco or nightclub present particular problems as the lighting is both low-level and always changing. Try supporting the camera, using a wide angle and a slow shutter speed (from 1/30 to 1/4 of a second.). Have some feature in the picture which is static, a decorative wall, a pillar, a balcony. Provided the dancers are not too close to the camera, you should get a clear picture of the static features with points of light and coloured trails from the clothes of the dancers splashed around it.

With a show, cabaret or similar indoor event it is particularly important to use the available light. It is unlikely that your flash

Left:
Concert shots need to show either the whole band or close-ups of the lead singers. Get close, use a telephoto lens and a very fast film to get the stage lighting effects.

Right:
Nightime shots have more interest if there is still light in the sky. (Chania, Crete)

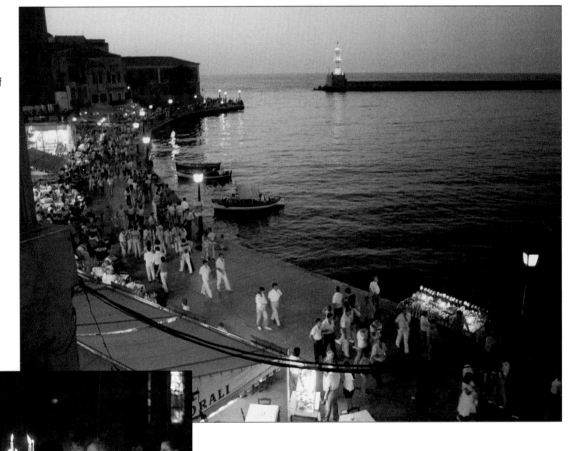

Left:
Candles are the only illumination in this photo, the film was medium speed (ISO 400). With such pictures, be careful not to measure the exposure only from the candles or the faces will not register. (Sacre Coeur, Paris)

would be powerful enough to have any effect on subjects further away than five metres and, in any case, if it did it would destroy the careful atmosphere created by the stage lights. So, switch it off or cover it. Ensure that your exposure is metered for the figures and faces and is not being fooled by any areas of darkness around the setting. Get as close as possible, zooming in to fill the viewfinder with your subject. Nothing is more disappointing than a dark print with a distant blotch of light that you recall as the high point of a fun night out! Do not limit your picture-taking just to the event though; quietly turn the camera around and take your companions reactions, too.

Decorative street lights and displays are a seasonal must for many families whether it's Christmas or seaside lights, we are always curious to see them and they mark the passing of the year. Use a medium speed film – ISO 100-200. Unless you can be driven very slowly and stand safely with your head and shoulders through a sun roof, it is best not to shoot these scenes from a moving car. Chose the time as daylight fades when the sky can be interesting colours. This will allow you about 20 minutes maximum to get your pictures.

Some people like to zoom in (or use a telephoto lens) to make close compositions of the individual lighting decorations. It does make exposures more accurate since there should be no large dark areas in the frame. But if the design is poor you will have nothing else in the picture of interest or atmosphere.

Wide shots enable you to see the environment in which the decorations are suspended. The light at dusk keeps the buildings visible and the sky interesting, as well as showing the sparkle of the decorations plus people and the lights of passing traffic. Slow shutter speeds (1/30 or 1/15 of a second) blur people, traffic and moving lights, leaving the static decorations sharp. If you are not using a tripod, steady yourself as you support the camera and fire the shutter with the self-timer. Try using the backlight/ exposure compensation button with wide shots having very dark areas.

For capturing firework displays you will need a medium to slow film and a tripod. To shoot pyrotechnics against the sky you may need to zoom in to a narrow angle to ensure they fill the frame. Set an aperture by dividing your film speed by 10 (for film ISO 50 set f5.6); set the shutter to B and open it during the display. The impressions of such an event are of many fireworks and not single ones; you can achieve the same effect in your picture by leaving the shutter open until several fireworks have gone off. Cover the lens between the explosions to avoid recording unwanted stray lights.

Bonfires, especially big ones, produce quite a lot of light – usually enough to photograph the faces (and a few of the antics) of people around it. When metering the exposure make sure the camera is not pointing directly at the flames which will give a wrong setting. Take the reading from faces instead. You may need to use the exposure compensation or backlight button.

Night-scapes are a fascinating way to record the atmosphere of a village, town or city. Such a pictures may well preserve the memory of an enjoyable visit in a way no daytime shot can do. High from an hotel window you can get an impression of buildings, shop windows, neon signs and busy or empty streets. Low down at ground level you might capture floodlit palaces and the shine on damp cobbles leading through great gates.

A tripod is a essential, particularly because slow films will best suit this type of subject; you can overcome the exposure problems by making sure that your metering is from neither the shadow areas nor the bright lights. If your camera can do it, take a spot reading from a lit area which is not a highlight. For centre metering, zoom in or change to a narrow angle lens to take the reading from the same area. Then reset the lens, setting the exposure manually. If you cannot do that either, use the exposure compensation/backlight button with the setting dictated by the camera. Use a cable release or the self timer for the shutter to avoid shaking the camera. Wide angle lenses (or a zoom at wide) are good for photos of bridges, harbours, whole streets and palaces. Narrow angles (or a zoom at telephoto) isolate single buildings, shop windows and other such details.

The intense clear light of flashlight in most of these after-dark situations tends to destroy all atmosphere. But there are a few occasions when, if you want to get a picture, there may be no alternative – for example, when you have to use an unsuitably slow film.

For recording the animation of people at parties you may need to shoot swift movements. This does not mean you have to use your flash blasting directly onto your subject; instead diffuse it with a diffusing panel or other device (sometimes supplied with flashguns). Alternatively cover the light with a thin sheet of tissue or a handkerchief. Try using the fill-in flash facility, if your camera has it, to reduce the intensity of flash. It may achieve a better balance with the room, restaurant or cafe lights. Finally, if the room has a white ceiling that is some three metres high, use bounced flash. By aiming the gun at the ceiling you produce an all-over, soft illumination. Ensure that the light is not pointing straight up, or it will also come straight down, giving all-over soft bags under the eyes. Point the light forward and up so that faces will be lit as much from the front as the top.

PETS

Successful animal pictures are satisfying to take and make excellent cards to send on many occasions. However, photographing pets can be a problem; often they will move too fast to register clearly, they blend in too successfully with their habitat to be easily visible or they simply they do not want to oblige on the day and just wander off! Only you know your pet well enough to keep it near the camera – or the camera near to it.

If possible, fill the frame with the pet. If this is not practical, compose a picture which puts them into a family group or the environment in which they live.

Close-ups of pets always give pleasure. If the face fills the frame try to ensure that even if the animal is not looking at the camera you can see both of its eyes. Also try to get the light falling on the side or front of its face.

Although a normal lens is quite adequate for all but the smallest of creatures, a telephoto or a zoom can be useful for keeping space between you and the pet - it may behave more naturally if it less conscious of your presence. Such lenses also have the advantage of throwing the background out of focus, making it less distracting in the final picture.

If you cannot get a close in, show the animal in its usual surroundings – in a sleeping place or in action, playing by itself or with a member of the family. To do this, confine it temporarily to a space which lets you photograph it easily. Try to ensure that the background is clear of too much fussy detail. If the animal is free to move have someone to help you keep it occupied and who can make it run or look where you want it to; get them to hold it if necessary. Animal movements are deceptively fast – even a cat cleaning its fur is remarkably speedy – so fast shutter speeds are essential.

Whether it is indoors or in the garden you will need strong light. Furry pets need to stand out from the background so choose something that is slightly lighter or darker than the animal's coat. The contrast should not be too great, though, or you may lose all detail in the final print.

Strong daylight with soft shadows can be very useful; also try using fill-in flash, especially in bright sun. Indoors use as much daylight as you can. If you use flash take it off the camera, diffuse and aim it at your pet from slightly above and one side . If you cannot take the flash off the camera diffuse it, or better still, bounce it from a card held near the flash.

Lower the camera to the height of the pet's eyeline.

Above:
Pets can be fun to photograph, if you have the patience to wait for them to perform!

Above right:
Aim to photograph your pet in action. Low camera angles exaggerate leaps. Fast shutter speeds and either strong light or fast film are needed to freeze the movements.

Right:
Food was placed near the camera and the cat the other side of the door to get this shot. It needed several tries to capture this action.

For aquariums and insect tanks put a dark card behind the tank and another in front with a hole cut in it big enough for the camera lens and viewfinder. This cuts down reflections, as does turning off the room lights and fitting a polaroid filter. Restrict movement inside the tank with sheets of glass. Put the camera close to the tank and fit a screw-in close-up lens (remember to operate within its focusing distance) or, if you have it, use the camera's macro focus. Light with your flashgun above and/or slightly to the side. If you cannot remove your flash bounce the light off a reflector above the tank.

TO TAKE SUCCESSFUL PET PICTURES

■ The camera must be capable of being focused quickly and accurately on close objects.
■ You need fast shutter speeds, 1/250 of a second or higher.
■ Use a fast film – ISO 400 or faster.
■ Use a narrow angle lens for small animals –` a zoom or telephoto at 100mm or more.
■ Use flash off the camera indoors, particularly for dark coloured animals.
■ Be patient!

Above:
Fur can absorb a lot of light before you see the texture. Flash was the only answer for this indoor shot of chinchilla kittens.

Below:
Exercise time or during a lesson are both good times to photograph your pony in action. Choose your position carefully so that gates and poles do not obscure the clarity of the animal's outline or limbs.

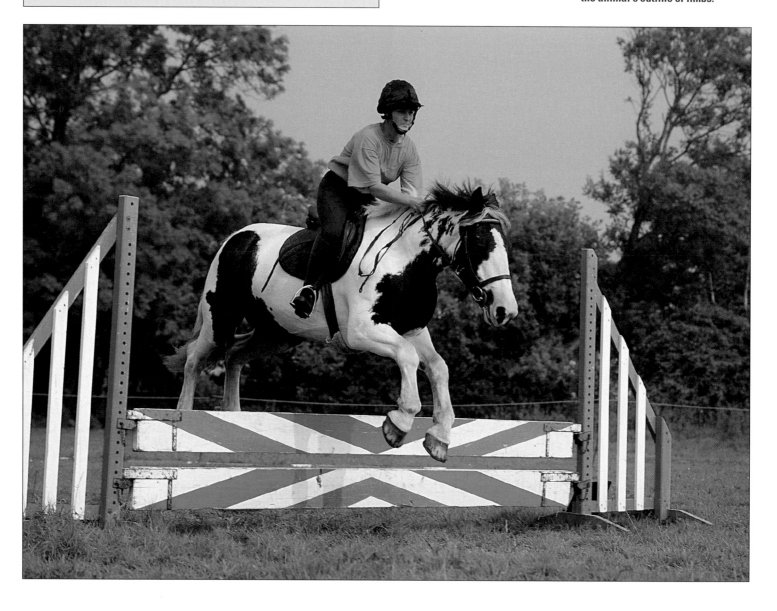

Left:
Try to photograph animals in their environment, although their natural camouflage can make them difficult to see.

Above:
Get close to a sleeping animal without disturbing the pose will mean zooming in to fill the viewfinder, or using a telephoto lens, plus a flash.

Above:
Filling the picture with a small animal means that you must have a camera which will focus closer than 1 metre, whether you use a zoom or not. To get a sense of the animal's size you need a familiar object in the frame for comparison. Here, the hands holding the sandfox.

Right:
To avoid the bars being too obtrusive in pictures of caged animals put them out of focus by using a wide aperture. Never use flash on the camera, or the cage will show as a bright foreground blur. You could use a separate flash from the top or side.

PHOTOGRAPHING FROM THE TV

If you take a successful picture from your television you must accept that it will show up every detail – that is the lines and dots that go to make up the television image plus any imperfections of your own receiving set, such as double or ghost images. Fast actions across the screen will almost always be blurred.

The secret lies in the shutter speed you choose. It must not be faster than the time it takes for the television to produce a single frame, the complete picture. The television picture is produced by a 'flying spot' of light of varying colour and intensity which is projected onto the picture tube in a series of horizontal lines. It does this 50 times a second to give the impression of a smooth image without flicker. But this frame is not actually complete; it is a half-frame, the flying spot only scans alternate lines. In the following half-frame it scans the other lines. Consequently each frame of a television picture is made up of two half-frames and the complete image only appears 25 times each second.

This is fine for photographic cameras with a shutter speed of 1/25 of a second when the shutter is open long enough to record both half-frames and make a complete image. But most modern cameras do not have this shutter speed; the nearest is 1/30 of a second. Using this speed means that part of the picture will be missing and it will show as a black bar across the frame.

Here are some pointers for taking successful pictures from your television.

• Slow to medium speed film (ISO 64-200) will give you reasonable depth of focus to result in a sharp picture.

• Room lights will cause treflections on the glass screen. Switch them off to avoid this.

• Adjust the screen picture to reduce the contrast and colour settings slightly. As your print is smaller than the screen size both will be restored.

• Support your camera with a tripod or books.

• Frame your picture so that the sides of the television image almost fill the width of your viewfinder. For Compact cameras go as close to the screen to fill the frame as your focus limit will allow, remembering to use the parallax compensation marks in the viewfinder. For zoom cameras with wide angles (about 28-35mm) do not zoom out to full wide angle or the picture will be distorted – the vertical lines will bow outwards.

• Switch off your flash or cover it to prevent any light escaping if it fires.

• For cameras which have it, set TV mode. If you cannot, switch to manual shutter and set a speed of 1/25 of a second or slower (usually this will be 1/15). For cameras unable to switch to manual and having aperture priority, observe the fluctuating shutter setting given by the television picture, then adjust the aperture until you are sure the shutter speed will be below 1/25 of a second.

• Use a cable release, pressing gently to prevent camera shake.

TRY THIS TIP

■ If your video recorder will produce a good still frame, record difficult or fast-moving sequences and photograph the moments you want from a still frame.

Beware – broadcast television pictures are covered by copyright law. You may only photograph them for private use.

Above:

It is usually necessary to reduce contrast and colour settings on the television set before taking screen pictures. Copyright laws limit the photographing of public transmissions.

Right:

Correct choice of shutter speed is essential for successful television screen shots. The dark bar across the picture indicates that the speed was too fast.

HOBBIES AND YOUR CAMERA

People with a hobby or special interest – gardeners, bird watchers and collectors of objects – all have one need: to take photographs which record with clarity the shapes, sizes and colours of that interest. It may be to show something to others or it may be a need to study something from elsewhere. The common aim, however, is accuracy.

To capture shapes with accuracy you will need to tune your eye to observe light as it falls on objects and defines them. You will need a sensitivity to the colour of daylight as weather and time change it and as it reveals or distorts colour. And you will need to identify different types of lights used in displays and exhibitions, so that you can buy the right film – or filters –-to avoid distorting colour casts from them.

Specialist photography for the keen amateur is outside the scope of this book but many people have a hobbies and interests which might involve the use of their camera from time to time. Some cameras are made to perform very specific tasks – shift lens cameras for photographing buildings, underwater cameras (with flash), cameras which allow many exposures on one frame to capture and analyze movement – but much can be done with an ordinary camera so long as you acquire a few extras relevant to your own needs.

Explore the use of these extras:

• A tripod and a cable release. For accurate recording you may need slow shutter speeds or powerful telephoto lenses; a tripod will prevent camera-shake, especially if you use a cable release for the shutter.

• Close focusing facilities. Different cameras have different minimum distances on which they can focus; if you want to focus on small objects near the camera consult your camera dealer about cameras (or different lenses) with short minimum

Above:

Make a record of valuable items. Photos can be useful to both police and insurance companies. A ruler in picture gives an indication of sizes.

Below:

This pottery model of the famous actor, Sir Henry Irving, shows him in the role of Cardinal Wolsey. It is photographed against the red robes of the original costume.

Left:

A camera is useful if your car is involved in a road accident. The pictures can show your insurance company the road positions and any damage. But do not leave the camera anywhere hot – both the film and the camera could suffer.

distances. Some cameras and lenses have a macro facility; usually this means that the lens can be switched to focus closely enough to give a 1:1 (life size) image on the film. Another possibility is a close-up lens. These come in different strengths and screw over the existing one. (Make sure it is possible to use them with your existing camera lens.)

• A polarizing filter can reduce or eliminate unwanted reflections when photographing objects through glass or surrounded by shiny surfaces.

• Other filters can reduce colour casts from different types of light or match the film you are using to the light source. (*See* section on Filters)

• A flashgun separate from the camera can be a flexible lighting tool. By using it from different directions it will help define shape, eliminate unwanted shadows to reveal detail, change the colour balance of light to improve colour rendition and freeze action. These are especially useful functions in bird and other wildlife pictures but buy a long connecting cable as you may need to position the flash near to a birdbath or an animal's run while having the camera under your control in another place. A second 'slave' flash can be used without a cable; it is triggered by the light from the first lamp.

• A survival blanket (the silvered material used for preserving body warmth by mountaineers and marathon runners and which has little weight or volume) is a very handy reflector for redirecting natural light to small living objects, such as flowers.

Above and left:
This four year record of the restoration of a boat kept track of both details and the pace of work.

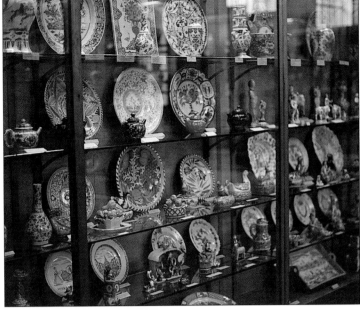

Above:

A close-up lens attachment, a small reflector and a tripod are all useful for the hobbyist wanting to record specal detail.

Above right:

Antique collectors may wish to record the details of objects behind glass. A polarizing filter will be essential to minimize reflections.

Above:

Pictorial records of garden visits may provide inspiration for new layouts!
(Dumbarton Oaks, Washington, DC.)

Below:

Hazy or even dull days let you take close shots capturing the detail and subtle colours that contrasty, bright sun can kill.

Beware –

• Some camera lens attachments reduce the amount of light passing through them. If your camera does not have TTL (through the lens) exposure metering you will need to re-calculate the exposure. Check with your camera dealer.

• Cameras with AF systems may be affected by some lens attachments. Again check with your camera dealer.

• There may be parallax problems when photographing close objects with a Compact camera; use the viewfinder guide markings.

• Wide angle lenses can distort and may be unsuitable for recording shapes accurately.

When photographing birds and other fast moving creatures, use very fast film. This will allow fast shutter speeds and smaller apertures to get greater depth of focus, even though you may be using a telephoto lens. Use flash to freeze extremely quick movements, such as birds in flight.

For garden scenes and individual plants use slow film to record detail and accurate colour. Wider angle lenses will give you greater depth of focus especially if you use slow shutter speeds. To photograph individual plants or flowers build a windshield and fix them with gardening wire to hold them steady in close shots. Use a reflector to get greater definition when shooting single blooms. Overcast daylight shows the colours of groups of flowers best

When photographing flat objects ensure that the camera lens is parallel to the original and check that the light is very evenly distributed. With objects like coins light more from one side to delineate detail. With objects behind glass try to eliminate light in front of it; take care over reflections, use a polarizing filter, switch off AF or check the camera instructions for focusing through glass. For accurate exposure, especially of dark or single colour originals, use a special photographer's neutral grey card.

Always take lots of shots of the same picture, varying the aperture or shutter speed, changing the exposure of each frame from two aperture stops (or shutter speeds) under-exposed to two aperture stops (or shutter speeds) over-exposed from the camera meter reading.

BUSINESS MATTERS

Most people buy a camera to use in their leisure time and forget that it has a number of very practical uses in their everyday or working world. One picture may save you writing a thousand words when it comes to accidents, losses, damage or making a claim for poor workmanship.

If you are unfortunate enough to have a car accident, should you have your camera, the photos you take could save an awful lot of written explanation when you make your claim, or protest your innocence. Make sure you take enough pictures; one roll of film is a small cost for good evidence. Always take wide shots to show both the road and the position of the vehicles involved. Then take close-ups, showing clearly the details of any damage.

If it's a sunny day, with hard shadows, use fill-in flash to make details in the shadows clear. Find angles which explain the points you want to make clear. If a shiny surface is dented, position yourself so that the light is reflected from the surface. The dents or scratches should then show more clearly. If a straight edge has become jagged move your camera to the side so that the edge shows clearly against another lighter or darker background. Whether you need to stand on a box or lie on the ground, get the angles which really explain what happened.

Use depth of focus. For edges to show against another background open the aperture so that the background will become fuzzy and show that edge with clarity. Dented paintwork, close-up shots and situations where you need clarity both near and far from the camera require a very deep focus and therefore very small apertures.

Bear these same points in mind if you need to take photos of damage to buildings. Your claim may concern fire, flood, a tree fallen on your garage or the resulting damage from a builder's incompetence or a landlord's neglect. Always show the general situation plus close-ups of detail. Use daylight for interiors if you can, but bounced or diffused flash help to light dark corners and will usually show details more clearly than direct flash.

While you are on site, always make additional notes of distances and dimensions. Transfer them to the back of the prints when you get them; you may well need them later.

Keep a photographic record of valuables as well. The police and your insurance company could find them useful after a robbery. (If the thieves broke in to your property you might want to show that damage as well).

To record valuables photographically:

• Use slow film to capture details. Use a camera support and cable release for slow exposures.

• Some small objects may pose difficulties. Unless your camera has a macro focus facility, getting close enough to record details clearly may mean you are too close for accurate focusing. In such instances, keep the camera at the distance which will keep the object sharp, then make an enlargement of a section of the negative.

• If paintings or other objects must be photographed under glass, beware of reflections. Try to get the light coming from the side and use a polarizing filter.

• Use diffused daylight, preferably from one side of the camera so that the object's shape will be seen. It may be necessary to move the objects nearer to the window to get a strong enough light. If you use flash, diffuse it through tissue or a thin white cloth, or bounce it from a card.

• Whatever the object, find a plain or uncluttered background. Use plain walls, screens, curtains (some distance behind to throw any pattern out of focus), or large sheets of paper (white or coloured). To help show size, include a rule (or something clearly identifiable such as a match box).

• Do not use wide angle lenses (or a wide zoom) which may distort; 45mm and upwards will produce better results.

Below and right:

When pictures may be used as evidence in a dispute, take several shots, both close and wide, to ensure that your pictures clearly include the points you wish to make.

SPORT AND ACTION PHOTOGHRAPHS

It is important to know something of the activity or sport you want to photograph, or at least observe it for as long as you can before you start taking pictures. Look for the key moments, which capture its excitement or attractions – not only the actions typical of playing a sport but the way concentration and the release of tension shows in the face and body of both participant and spectator. Note the patterns or cycles of movement which allow you to predict the key moments.

Get the best viewpoint you can, preferably with an uninterrupted view of the action. Low positions dramatize actions and often leave the background clear of distracting objects; high positions reveal patterns of activity where teams or groups of people are involved.

For very fast moving actions – and especially for AF cameras which may not cope with rapid changes of distance – it may be best to keep the camera steady, frame a good shot and preset the focus, letting the action move into the frame before pressing the shutter. With sports which take place on a pitch or track you could move the camera, panning with the action, pressing the shutter as you see the key moments develop.

Where you need the key moments to be in sharp focus, you will have to freeze the action. This can be done either with a fast

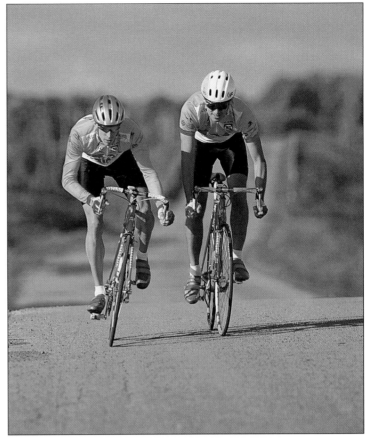

Left::
Indoor swimming pictures need flash to freeze the fast actions and careful choice of camera angle to indicate direction. Slower speeds and overhead angles can emphasize a more dreamlike quality in the movements of both body and water.

Above:
For track or road events, if possible, position yourself ahead of competitors; you will need much faster shutter speeds if you shoot from the side. Pre-focus on a part of the route which is easy to see in the viewfinder and release the shutter just as the subject is about to get to the focussed spot.

Below left:
With fast moving team sports unless you have a powerful zoom or telephoto lens and very fast shutter speeds it may be best to frame an interesting shot which at some point will contain the key moment, then wait for that moment.

Below:
If you can get close enough, pan with the action, if your autofocus is slow you will need to constantly change focus manually and use a fairly fast shutter speed which will arrest most likely movements.

shutter speed or flash. Movements travelling from side to side of the picture – and where the subject is filling the frame – are the most difficult to freeze and need the fastest shutter speed or most powerful flash. Movements coming to or going away from the camera and only filling a small part of the frame are easier and need a less fast shutter speed or less powerful flash. But there are some fast moving subjects where the movement slows down or almost stops of its own accord. Just as a swing slows down and stops at the top of its arc so do many human movements – skateboarders riding up a wall, a tennis server's swing and high-kicking dancers are some examples. Identify that moment and fast shutter speeds become much less necessary.

Remember that no subject will seem to be moving unless there is a clue to movement in the picture. This could be the shapes a person's body makes, the compositional lines made by a track or surface over which the subject is travelling or blurring within the frame.

This deliberate blurring can be caused by following the action with your camera using a shutter speed that is only fast enough to keep the subject clear – not the background as well. This works well when your subject is lighter than the back-ground. A similar effect can be got by using flash with a slow shutter speed; this should let in enough light to produce an image but not be fast enough to freeze action. By panning the camera with the action you also blur the background but the flash will freeze the action of the closer subject. Thus only the essential key moment is sharp; all else is streaky and blurred.

In other cases movement can be suggested by blurring parts of the action itself. There are actions where the body may be fairly still but the limbs are moving. Choosing a shutter speed not quite fast enough to freeze those limbs can be very effective in suggesting some movements.

Unfortunately many ordinary cameras do not have a telephoto lens, or one powerful enough to get you close enough to the action. In that situation shoot pictures which give atmosphere – spectator reaction or the team returning to the cricket pavilion. The other common problem is that the shutter speeds will not be fast enough to freeze the action. In such instances, it is best to look for the split second when the subject is slow moving or the comparatively still moment at the end of an arc of movement.

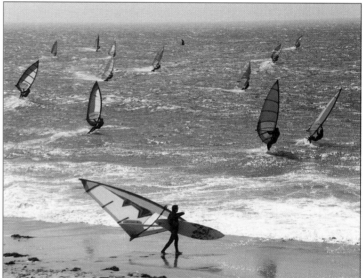

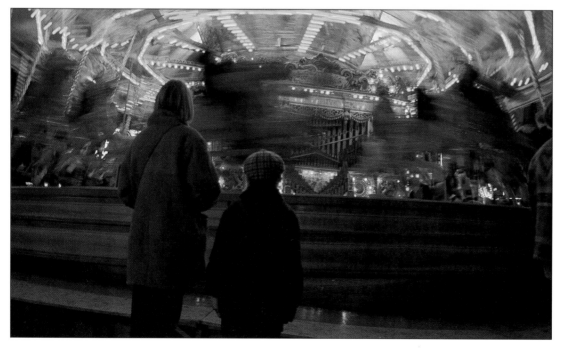

Above and left:
Movement often needs to be displayed in the shape of the body. Although ice skaters move fast their body movements do not always show it.

Above:
Races at sea benefit from being seen from overhead; light from behind the sails is a pictorial bonus. (Windsurfing, California)

Left:
Sometimes action pictures can use blurring to indicate movement.

CHECKLIST:

■ Use fast film, at least 400 ASA, to help you use fast shutter speeds. Re-rate the film if it will give you a faster shutter speed.

■ If you are shooting on transparency film remember to use the correct type for the venue – daylight for outdoors; tungsten for events under artificial light.

■ Invest in a camera support (a tripod or monopod) if you expect to do this sort of photography frequently.

■ If you want to use flash, especially in a public venue, check that there are no restrictions.

■ Check that your flash is charged up – and have fresh batteries with you.

■ If your camera has an autowinder, switch it off. For some events it may not rewind fast enough causing you to miss things. It is better for you to learn to anticipate the key moments than lose them.

SUGGESTED SHUTTER SPEEDS TO FREEZE ACTION

Distance of subject from camera	Movement across frame	Movement towards camera
People talking or walking, slow moving water, light wind in trees.		
1 - 3 m	1/250 sec	1/125 sec
3 - 5 m	1/125 sec	1/60 sec
Running, swimming, children playing, horses trotting, waves.		
1 - 3 m	1/500 sec	1/250 sec
3 - 5 m	1/250 sec	1/125 sec
Horse-racing, skiers, cars and cycles at 30 mph.		
3 - 5 m	1/1000 sec	1/500 sec
10 m	1/500 sec	1/250 sec
20 m	1/250 sec	1/125 sec

There are lots of opportunities for suggesting action but these shutter speeds are only a guide to a successful picture. It is best to take several shots, each with a slightly different speed and analyze the results.

Local shopping centre photographic processors offer fast economic services using automatic developing and printing processes with the latest technology, mostly producing work to very high standards. If you and your camera are working well – in other words the pictures are posed, composed and exposed to a competent technical standard –then you should be happy with the results.

Would all photo life were like that! There will always be times when things did not work out and you know or suspect that your photos may be affected. If the pictures are important to you they may need something more than the automatic services can deliver, such as a hand printing service. It can not only correct some of your faults but make enlargements from sections of your negatives, giving you the chance to improve your pictures by recomposing them. Such a service may be available from your usual processor or you may need to consult a trade or classified telephone directory to find it.

HOW YOUR FILM IS PROCESSED

As soon as films arrive at the laboratory, they are coded so that they will be returned to the right customer. The coding may be a label attached to the end of the roll or a number exposed on the

A complete colour processing kit - things you need to buy for the processing of colour negative film and prints. You will also need a lightproof room and running water.

film itself. Then all films of the same type are joined to form a long roll.

Processing consists of developing your film to produce a negative image then shining a light through it onto photographic paper to make a positive (or print). This in turn must have its image developed and stabilized or fixed. Negatives are developed by the C 41 process and the developing machine has separate tanks to hold a different chemical for each stage of the six-stage process. The chemicals are rigorously temperature-controlled and changed as needed without stopping the machine, which pulls its long roll of joined films continuously through the day.

The film roll then goes to the printing machine. This feeds the frames one by one to the negative carrier where a beam of light is shone through them to a prism. The beam is split, passing one image to a zoom lens which focuses it on the photographic paper, the other beam passes to a computer-controlled colour scanner which analyzes the image in three ways. Firstly, it assesses how light or dark the whole frame is to calculate an exposure. Secondly, it checks the colours and, thirdly, it works out which correction filters should be used, and for how long. The machine can also show a televison screen image so that the operator can make manual adjustments if necessary.

The operator can now open the lens shutter and expose the paper. The paper roll then travels through developing, fixing and rinsing tanks; finally it is dried before being cut into individual prints. These are sorted and then reunited with their negatives, ready to go to the customer.

TIPS TO TRY

■ If you think you may need more than one print of a picture, take the shot as many times as you will need prints; it works out cheaper.

■ If you will need duplicates of most pictures on roll, have each frame printed twice when the film is first taken for processing; reprints cost more money.

DOING IT YOURSELF

The Pros and Cons of doing your own processing.

PRO's
• Gives you control over your pictures, allowing you to correct and improve them to get the best possible results.
• Could eventually save money, avoiding printing unwanted or unsuitable photos.

CON's
• Takes time.
• Needs a modest investment of money for equipment.
• Needs an area big enough to work in, with a supply of running water ideally, yet allowing you to keep wet, or chemical work, separate from the dry tasks. It must also be capable of being completely darkened for periods of a few hours.

Equipment and Methods

For colour negative film development you will need:
 A standard developing tank
 A water bath (plastic washing-up bowl)
 A photographic thermometer
 Two 300ml measuring cylinders
 Two 500ml storage bottles
 C 41 process development kit

The equipment and chemicals are made by most of the major photographic and film companies and are widely available from photographic retailers.

The procedure is very similar to developing black and white film but the timings and chemical temperatures are more critical.

There are three basic stages which take about 25 minutes to complete:
1 A colour developer bath; this produces a silver negative image which releases the dyes making the colour images in the emulsion coating the film.
2 A bleach/ fixing bath; this removes the silver leaving the dye negative ready to print.
3 A stabilizer bath; this helps to preserve the colour dyes in the negative.

For processing colour prints you will need:
 Three shallow dishes and a water bath the size of the largest prints you want to make, OR
 A temperature controlled processing tank
 An enlarger
 A colour safelight (this can be expensive, it is possible to work in the dark)
 Processing chemicals, including a colour developer and a bleach fixer

These are the stages:
• Use the enlarger to project the image of part or the whole of individual negative frames on to the chosen size of paper; a number of test strips or trial prints will need to be made to correct the colour values.
• Pour the processing chemicals into the dishes and put in the exposed paper, following the manufacturer's instructions. You may need to include a stop bath.
• Each print may take about seven minutes to develop.

Timing is critical in colour processing. Timers like these can be used to help automate parts of the work.

PICTURE FAULTS

ONE OF THE BEST and quickest ways to improve your photography is to study your pictures for mistakes. But before you blame yourself for everything, you need to know at what stage in the making of a picture the fault has occurred. Was it when you took it, or was it during the processing stage when the negative film was developed or the print made?

To trace a fault check in this order:

• Is the fault only on the print? If so, it is a processor printing error.

• Is the problem visible on the negative? If so, it is either a taking fault or a processor developing error.

How to check your negatives

If the picture was underexposed: -
• The shadows will look empty, lacking in contrast, detail and colour. The mid tones and highlights will look OK, showing good detail.

If the picture was over exposed:-
• The highlights will look dense and the colours will be too dark to see separately.

If the picture was correctly exposed but the film underdeveloped:
• The highlight areas will look weak; the shadow areas will have some detail but when printed they will have poor contrast.

If the picture was correctly exposed but the film overdeveloped :
• The negative may look contrasty, the highlights will be dense, the shadows will have poor detail and the film's grain will be noticeable.

HOW TO CHECK PROBLEMS FROM PRINTS

Prints too dark (and negative very pale)

Possible reasons:
• Under exposure, not enough light.
• Insufficient light at the place and time when you took the picture.
• False exposure set by automatic meter due to shooting into the sun or including a bright area or light in viewfinder. (*see* Exposure Compensation)
• Flash not switched on.
• If your flash fired, the lamp may have been covered by hand or the camera case, or the subject was too far away for the power of the light (check minimum flash distance in camera instructions).
• If all the pictures on the roll are dark, the film speed was incorrectly set.

Prints not sharp (and negative similar)

Possible reasons:
• If background is sharp but moving objects are blurred this is due to too slow a shutter speed being used (see Action & Sport).
• If some part of the picture is sharp but not the area you intended, this is a focusing fault. With fixed focus cameras the subject may have been too close to camera (check camera instructions). If your camera has central area auto-focusing and your subject was off-centre, you did not use auto-lock. (See section Cheating the System). If manual focus, and the fault is persistent, check the camera and also your eyesight; you may need an eyesight correcting attachment for your viewfinder.
• If all the picture is blurred the cause could be camera-shake. The shutter speed used was too slow for the camera to be unsupported. Or if the camera was on a tripod, it was knocked or subject to vibration as you took the picture.

Above top:

Camera shake, whole image blurred. Shutter speed not fast enough to overcome camera movement or vibration.

Above:

A correctly exposed negative. Details visible in the highlights, colours can be seen easily, tones strong also with colour information in the shadow areas.

Prints a strange colour

Possible reasons:

• If the picture is yellow and was taken by artificial light, the processor did not correctly assess or filter during printing. Print film is meant for daylight; your processor can help to correct the colours during printing but it is best to tell the laboratory that you have artificial light pictures on the roll when you take your film in. A hand printing service may be the answer.

• Old film, used after expiry date.

• Film badly stored before or after exposure. (Film should be kept below 25 C. High temperatures can affect the colour of films within hoursand age can affect it, too. Process within a few weeks of use.)

Above left:
Pink cast over all print especially noticeable on white background wall. Stale chemicals used by processor. Ask for a new print.

Above:
Yellow colour cast. Picture taken by artificial light but not corrected in printing.

• If colours are dull and an overall pink cast, check the negative; if it has good contrast this could be a processor fault, probably from using stale chemicals. Ask for the print to be done again.

• If there is no problem on the negative, it is a processor error; probably the print has been made with incorrect filters. Ask for it to be done again.

Left:
Picture Under-exposed. Too little light on film. Wrong exposure programme selected. Metering of wrong picture area. Wrong film speed setting.

Right:
Picture over-exposed. Too much light on film. Wrong exposure programme selected. If you have auto-metering, metering of wrong picture area. Incorrect film speed setting. Exposure compensation accidentally activated. Metering window accidentally covered.

Prints have unusual light or dark marks

Possible reasons:

• Dark areas may be due to a finger or camera strap in front of the lens.

• Dark areas at the corner of the picture may occur from an unsuitable or badly fitting lens hood.

• If there are black or orange marks, often square, at the edge of the print, with a corresponding area on negative possibly with a code number, check frame numbers at the edge of the film. If the affected area is before the first or last frame it means that your camera allowed you take pictures before or after the expected total length of exposures. The processor, not knowing there is a picture there, hasused this area for the internal coding system (See Processing Your Film). The error has been compounded by printing the affected frame. Check your camera loading instructions.

• Light streaks (white or orange), especially if they extend beyond the picture area and on to the sprocket holes at the edge of the negative film, occur if the back cover of the camera fits badly or was opened accidentally.

• White lines along the print, and also on negative, are caused by scratches. There may be a fault – dirt or grit in the camera – or the film may have been damaged in processing.

• Thin white lines or dots on picture are usually caused by dirt, dust and hair. If they do not ocur on the negative, it means there was dirt in the processor's printing machine. Ask for a new print. If they are also on the negative, there may have been dirt from the camera when the film was exposed or there were poor processor conditions during the drying of the film.

• Thin shaft of white or coloured light across the picture which does not extend beyond exposed frame on negative is flare, caused by light shining into camera. The problem can be reduced by the use of a lens hood attachment.

• Sharp white light in any area of the picture usually occurs when a flash is used, and is the caused by reflection of the flash, especially if the picture was taken through glass.

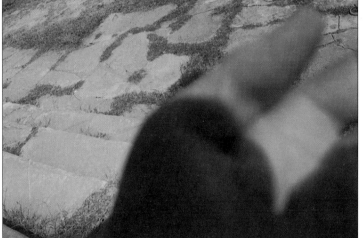

Above:
Flash under exposure. The central and largest area of this shot is white, consequently the flash system calculated little light was needed.

Below:
Flash not activated. Foreground figure not lit due to the exposure being calculated from the centre area. As this is bright the system did not think the flash was needed. Cure problem by putting subject in the centre of the viewfinder.

Above:
Hand in front of lens. See camera handling section. Ensure that all camera straps, case fronts or other attachments do not swing in front of camera.

Below:
Light entering the back of the camera. Camera opened accidentally or back securing mechanism faulty. If fault persists on next film roll consult dealer.

Print not showing the expected picture

Possible reasons:

• The subject too small is a common problem caused by the failure to use the viewfinder properly when composing a picture. Always try to fill the viewfinder with your subject by moving towards it or it towards you, or by zooming in.

• Part of the subject 'cut off' also suggests a failure to use the viewfinder properly, especially the white guidelines. Check camera instructions.

• Vertical lines not upright and horizontals tilted showing on many pictures is probably due to incorrect shutter release technique. You are probably pushing down the shutter button and also the camera at the moment of exposure. Push or squeeze it more gently.

•Pictures overlapping means the film is not winding on properly. Check camera instructions and with your photographic retailer.

• Two pictures on one frame (and also on the negative) is a double exposure caused by a film winding fault. Check the camera instructions and also consult your photographic retailer.

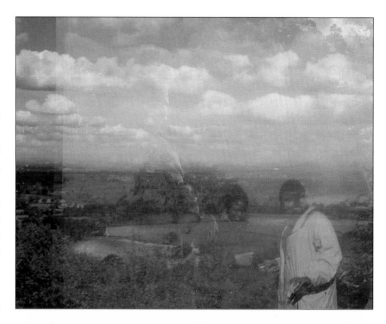

Above right:
Double exposure, two photos taken on same film frame. Double exposure facility wrongly activated or camera fault. Consult dealer or repair shop.

Below:
Flash over exposure. Most dedicated or built in flash systems calculate their exposures from the central picture area, which in this case is the far distance. The flash has used full power to reach the horizon, burning out the foreground subject. Place subjects in picture centre to avoid the problem.

Right:
Flash not powerful enough. A typical problem, the performers are too distant for the power of the flash. Check your camera instructions.

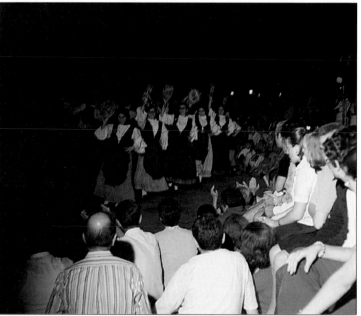